MEET CUTES
NYC

MEET CUTES

(NYC)

True Stories of Love and Connection

Aaron Feinberg, Victor Lee
& Jeremy Bernstein
Creators of Meet Cutes NYC

Photography by
Jeremy Cohen

ARTISAN | NEW YORK

Copyright © 2025 by Meet Cutes NYC LLC

Photographs copyright © 2025 by Jeremy Cohen

Hachette Book Group supports the right to free expression and the value of copyright. The purpose of copyright is to encourage writers and artists to produce the creative works that enrich our culture.

The scanning, uploading, and distribution of this book without permission is a theft of the author's intellectual property. If you would like permission to use material from the book (other than for review purposes), please contact permissions@hbgusa.com. Thank you for your support of the author's rights.

Library of Congress Cataloging-in-Publication Data is on file.

ISBN 978-1-5235-3008-3 (hardcover)
ISBN 978-1-5235-3010-6 (ebook)

Design by Becky Terhune
Cover design by Rodrigo Corral

Artisan books may be purchased in bulk for business, educational, or promotional use. For information, please contact your local bookseller or the Hachette Book Group Special Markets Department at special.markets@hbgusa.com.

The publisher is not responsible for websites (or their content) that are not owned by the publisher.

The Hachette Speakers Bureau provides a wide range of authors for speaking events. To find out more, go to hachettespeakersbureau.com or email HachetteSpeakers@hbgusa.com.

Published by Artisan,
an imprint of Workman Publishing,
a division of Hachette Book Group, Inc.
1290 Avenue of the Americas
New York, NY 10104
artisanbooks.com

The Artisan name and logo are registered trademarks of Hachette Book Group, Inc.

Printed in Canada (TC) on responsibly sourced paper
First printing, August 2025

Cover © 2025 Hachette Book Group, Inc.

10 9 8 7 6 5 4 3 2 1

To all who want to believe in love

Contents

Introduction 11
The Meet Cutes Rule Book 14
Things the Couples Have Taught Us 17

The Stories 18

Love at First Sight 21
All the Right Signs 22
Hot Sweet Apple 25
Pizza Queens 26

Second Chances 29
Fell into a Kiss 31
From Enemies to Lovers 34
More Than Brunch 37
Each Other's Safety 38
Comforting and Comfortable 41
Alone Time 42

Bars and Clubs 45
The Thing 47
Support System 48
Together on a Bench 51
A Real Knockout 52

California Dreaming 55
Five Days In 56
Strike 58
Where to Meet People 60

Coworking 63
Oh, Darling! 65
The Real Deal 68
Business Travel 71
Run Away with Me 72
The Evolution of Us 75
The Whole Package 76
Summer of '61 79
Can't Live Without Her 80
Besties 83
Not an Asshole 84
Love Is in the Air 87
It Should Be Easy 88
The Secret to Staying Together 90

Music 93
A Perfect Match 95
Just Looking at Her 96
Excited for Every Day 99
Float Your Boat 100
Continue the Conversation 103
My Rock, My Roll 104
365 Smiles 107

Family Ties 109
Kind of Arranged 110
Hey, Beautiful 113
Play That Music 114
Danced All Night 117
Easy Breezy 118
Four Coffees 120

On the Apps 123
Dance Partners 125
Pasta Date 126
Star Power 129
Love at First Bike 130
On a Rooftop, in the Summertime 133

Great Hearted 134
Just Hanging Out 137
Comfort Food 138
Unrelentingly Kind 141
Taking Care 142
Raise the Stakes 145
You Don't Have to Ask 146
Unlikely Lovers 149
The Dangers of Our Job 151

Out and About 153
Off the Wall 155
Right Here, Right Now 157
Warm Milk 160
Really Tall, Cute Guy 163
Yes, Chef 164
Fell Down Stairs 167
Two Strong Minds 168
Good Moves 171
Destined to Be 172
See What We See 175
July 4, 1979 176
All the Ways to Say No to Meet Cutes 179

Mutual Friends 181
First and Last 182
Fancy Meeting You Here 185
Caught in Your Eyes 189
Late Lunch 190
Warming Up 193
Come On Baby Light My Fire 194
That Gut Feeling 197
Authentic and Original 198
Third Time's the Charm 201
It's a Wonderful Life 202
You Never Know 205
Cat Tats 206
Sealed with a Kiss 211

Arts and Culture 213
Love Through the Lens 215
From Dancing to Dating 216
Creative Minds 218
Love Onstage 221
Every Day an Adventure 222
Fashion Romance 225

School Days 227
Party School 229
Sharing the Journey 230
Nursing Love 233
More Than Friends 234
Step-by-Step 237
A Million and a Half Years Later 239
Ice-Skating 243
Love and Friendship 244
From Geometry to Prom 247
Has My Heart 248
West Side Y 251
The Thing Couples Are Most Looking Forward To 252

Acknowledgments 254

Introduction

"Excuse me, are you two a couple?"

That's the first question Jeremy always asks when the three of us go out on the streets of New York to film videos for our Meet Cutes NYC channel. We never reveal our faces on video, but it's gotten to the point where people recognize his voice from having seen our content on TikTok, Instagram, Facebook, and YouTube. (Fun fact: Jeremy actually won "most distinctive voice" in his high school yearbook.)

His next question for a couple is "Can you tell us the story of how you first met?" If the three of *us* were asked this question, our story would be this one: Aaron and Jeremy were friends from earliest childhood on the Upper West Side. Then Aaron's family moved to Port Washington, New York, where he met Victor and they became close friends. Later, Aaron and Jeremy reconnected as college roommates at Binghamton University—after having lost touch for a long time. And then we all hooked up as adults in our late twenties in NYC.

Victor had the initial idea for Meet Cutes. He was inspired by the stories of couples he saw in his own life, plus a fondness for man-on-the-street interviews. He mentioned the idea to Aaron almost as a joke, but Aaron saw its potential and got Jeremy involved because he was the only person Aaron knew who could talk to anyone.

At the time, Jeremy had a job selling renewable energy at a folding table set up on the street, so he was already a professional at talking to strangers—by now, he considers it second nature. We hit the streets and posted our first interview in February 2023. Jeremy asked the questions, and Victor and Aaron filmed.

What's funny is that we weren't very active on social media before starting the account. And we wouldn't have considered ourselves to be romantics. But we got together around this. There was something exciting about demystifying the way couples meet, especially on the streets of New York City, a place perhaps better known for single people, tricky dating culture, and—not to put too fine a point on it—unpleasant pedestrians. What if we could get out there and explore genuine love and connection? How amazing would that be?

Initially, we thought we'd just focus on stories of how people had met. But viewers on social media would comment, asking for more on the couples. So we started asking additional questions, haphazardly at first, until we got into the flow of it all. We settled on the set of questions we more or less use now: "Can you tell us the story of how you first met? What was your first impression of your partner? What's your favorite thing about them? What's the secret to staying together for this many years? What are you most excited for in the future?"

We didn't have high expectations at first. Who wants to do an impromptu interview on the street? New Yorkers have places to be! And we thought that getting *both* people in a couple to stop and talk to us would be the challenging part. It turns out, couples like to do things for each other—when one person in the couple is interested, they can generally get their partner to stop and talk as well.

It's amazing to see how often those first moments of hesitancy transform into smiles and nostalgia as people start to tell their stories. That's not to say we don't get a lot of rejections and brush-offs. We get a *ton*. For one thing, it can be hard to tell who is or isn't a couple. And even actual couples don't always want to stop and talk.

But it's all worth it for the ones who do. In the early days, we were filming on our lunch breaks and on the weekends. Nowadays, we all work on the channel full-time. We film about five days a week and try to post every day. Hours and hours of shooting can result in only a few usable videos. The noise of the city alone is an obstacle—all it takes is one siren to ruin an otherwise great interview.

We shoot mostly in Manhattan, Brooklyn, and Queens, and in areas like SoHo, Harlem, the Upper East Side, Rockefeller Center, Williamsburg, and Jackson Heights. We've interviewed couples of all ages and from all walks of life, and each story is rom-com-worthy in its own right. We've spoken with couples who met on the subway or while traveling abroad; couples in arranged marriages; couples who caught one another's eye at a nightclub in the 1980s; couples who've known each other since childhood; and couples who met at dinner parties, rock concerts, weddings, and DJ lessons. We've documented thousands of stories of true love.

We work closely as a team throughout the whole process, deciding which videos to post. But there is a secret fourth team member: Aaron's mom.

She updates us daily on what's happening in the comments. She's like Meet Cutes security—if there are narratives that are trending, she alerts us to what the community is saying.

And it really is a community! It's grown beyond our wildest dreams. We have millions of followers across the different platforms, with ten thousand new people joining every day. We're incredibly grateful for the level of support we've received, especially in such a relatively short time. We even have followers in Nepal, Saudi Arabia, Australia, and other countries around the world. It's truly mind-blowing.

But at the same time, it makes sense. We've heard from many people that the site has offered them hope. That it's refreshing to see real, authentic love stories amid the highly curated content on social media. We all share the desire to find love; it's innately human to yearn for genuine and meaningful connection. And it's simply beautiful to see people who have found that.

This book is a celebration of some of our favorite couples. Some are fan favorites from the feed; some we've just talked to recently and are appearing for the first time in these pages. Each story is also accompanied by a gorgeous original photograph of the couple from the honorary fifth member of our team, the talented Jeremy Cohen.

We'll also let you in on some tips and tricks we've learned along the way—about both finding love and filming love.

We can't imagine a better way to spend our time than to bear witness to the love stories of thousands of real couples, to share those stories with others, and to remember every day that love is real, and grounded, and not going anywhere. What an honor it is to be able to share proof of that with you here.

The Meet Cutes Rule Book

♥ **Don't start before eleven a.m.** Sleepy people don't want to talk.

♥ **Likewise, look for folks with coffee cups in hand.** Caffeinated couples are more likely to agree to be interviewed. (Also, we carry coffee ourselves; it's relatable.)

♥ **Get used to hearing no.** Don't take rejection personally. There's going to be a lot of it.

♥ **Be ready to sprint across the street if we spot an interesting person or a great outfit** (we're totally going to get hit by a car one day).

♥ **If one of us wants to approach a couple, go for it no matter what.**

♥ **Keep our eyes open.** Look in all directions.

♥ **Stop for noise.** If we can get someone to pause what they're saying when a siren, loud car, or random saxophone starts up, we might be able to salvage the video.

♥ **Crouch to the height of the people we're talking to.** We are taller than a lot of our interviewees, but we don't want to look down on anyone.

- 💗 **Smile! Keep it upbeat and positive.** Bring the good energy, and keep it moving.

- 💗 **Dress approachably.** Wear something colorful (Aaron has a purple hat that he feels gives off a friendly vibe). Don't wear dark colors. Athleisure is generally inviting. And be well-kempt (don't let those beards get too long).

- 💗 **Use lots of hand gestures.**

- 💗 **Crack jokes to keep the energy up when things are slow.** As so many couples will tell you, humor is key.

- 💗 **Don't try to hide behind the camera.** We make it really obvious what we're doing. We don't want people to feel like we're being sneaky.

- 💗 **Bring water and snacks to avoid getting hangry.**

- 💗 **Find streets that are crowded but not too crowded.**

- 💗 **If things are going well, don't move spots—keep staking out the same corner** (never leave a place where we're having a good time for someplace else where we think we might have a better time).

- 💗 **Always keep the camera on.** Never miss a beat. The best content comes from unforeseen moments.

Things the Couples Have Taught Us

- ♥ **Communication is nearly 100 percent of the answer to long-term success.**

- ♥ **Don't stop *dating* your partner** (don't unconsciously fall into a routine or stop doing the things you love together).

- ♥ **There's not one direct path to love.** Everyone needs something different from their partner.

- ♥ **There's no one way a relationship should look.** We've seen open relationships, long-distance relationships—different arrangements work for different couples.

- ♥ **Build happiness outside the relationship.** Many of the happiest couples are happy both apart and together.

- ♥ **Talk about the future and what you'd like to build together.** Have something to look forward to.

- ♥ **Respect each other.** Listen to each other. Be kind.

- ♥ **Support each other's endeavors.** Have each other's backs.

- ♥ **Recognize that each individual is evolving and that you each will change over time.** Give each other space for that.

THE ST

TORIES

LOVE AT FIRST SIGHT

It can be tempting to think that love at first sight doesn't exist. But these couples are here to tell us that it most definitely does. For people who've experienced this kind of powerful, bolt-from-the-blue love, life will never be the same. One minute they're minding their own business, the next they've met a new person and fallen head over heels in love. Imagine what that must be like.

Brandon & Kevin

"All the Right Signs"

Can you tell us the story of how you first met?

Kevin: I will tell you the story, and Brandon will sign it for you. I was watching a performance at New York Live Arts called *Fresh Tracks*. Brandon came out onstage and was moving in their incredible, unique way, signing and dancing, and I thought, "I'm going to spend the rest of my life with this person. Who is this person? They're going to be a huge star. They're so inspiring. I have a hunch that I'm going to know them forever." We met in the lobby afterward, and the rest is history.

What did you do on your first date?

Kevin: Let's just say, we went to a very cool, sex-positive naked party in 2019.

What are your favorite things about each other?

Kevin: That we get to experience everything together. We're creative partners, business partners, life partners, and Brandon continues to blow my mind every single day.

Brandon: My favorite thing about Kevin is his honesty. He can't lie to me because I can see it.

Kevin: We're truth machines.

Brandon: We are truth machines. I recently sang something for him and I watched his reaction. I know his reaction when something's good.

What are you most excited for in the future?

Brandon: We're so excited to share our art with a wide audience. We have so much fun bringing amazing groups of artists together and making things across disciplines. We're thrilled to be queer artists living in New York City right now.

SoHo

Lonneke & Joost

"Hot Sweet Apple"

Can you tell us the story of how you first met?

Joost: I was at work, and I went to get lunch, and she was working at the grocery store. I thought, "Okay, that is an amazing girl." I ordered the "hot sweet apple." I went back four times and ordered the same thing. Then I sent a big bouquet of roses to her, and it was from "Hot Sweet Apple." That's how we met. Then we went out for dinner. That was twenty-four years ago. She was eighteen, I was twenty-one.

Lonneke: Now we're very old—

Joost: Now we're very old.

Lonneke: —and still together. [*Laughs*]

Joost: We have two children, one eighteen and one fourteen.

Twenty-four years in, what's your favorite thing about each other?

Lonneke: He's very funny. He thinks he's very funny, and I think he's very funny. [*More laughter*]

What's your favorite thing about her?

Joost: We have a lot of fun together, still, to this day.

What are you most excited for in the future?

Joost: Having more fun and doing a lot of nice things with our family. That's it. That's the only thing.

SoHo

Stefanie & Jackie

"Pizza Queens"

Can you tell us the story of how you first met?

Jackie: We met on TikTok. I saw a video that she posted. She was doing this sexy thing with her mouth and her lips and her tongue and her teeth. I was like, "Who does this beautiful mouth belong to?" I hit her up and said, "You are so sexy. I need you in my life." We've been together going on two years.

What did you do on your first date?

Jackie: We were long-distance at first. I was in Georgia, she was here, so when we met, we *met*, if you get what I mean. That was our first date.

What advice would you give to a couple that's doing long-distance for the first time?

Stefanie: You got to trust each other.

Jackie: Yes, and good communication. Because you're not physically there, and you can't really feel each other's vibes. That's the best thing to do.

What's your favorite thing about her?

Jackie: Everything, everything. I'm super attracted to her. Everything she does, her essence, her vibe. I usually get annoyed with people, and she hasn't annoyed me in two years. This is it for me.

What's your favorite thing about her?

Stefanie: Same. Same exact answer.

What's your favorite thing to do as a couple?

Stefanie: Go get pizza.

Jackie: We have pizza dates.

Stefanie: We're on one right now!

What are you most excited for in the future?

Jackie: I'm just looking forward to her being my wife.

SoHo

SECOND CHANCES

Relationships don't always work out right away. Some couples miss each other the first time around. Some don't get along, don't admit their feelings, move away, lose touch. But something pulls them back toward one another. Some folks break up and then rediscover each other in the most unexpected places. After all, couldn't we all use a second chance sometimes?

Mike & Karen

"Fell into a Kiss"

Can you tell us the story of how you first met?

Mike: I'll never forget how we met. Karen and I were at the same university. There was a big lecture hall. She was dressed sort of hippie-ish, with long hair, and I immediately thought, "I want her to sit next to me." I *willed* her to sit next to me. And lo and behold, she sat next to me.

Karen: I did notice the cute guy sitting there.

Mike: I asked her out right after class. And she, of course, told me she had a boyfriend. "I'm quite serious about him, blah-blah." And for ten years, either she was in a relationship or I was in a relationship. And then finally, she wasn't and I wasn't. And she asked me out. For our first date, we went to the Museum of Natural History. We were together for two years, and then because of my behavior, she said goodbye.

Karen: When I broke up with Michael, it was on my birthday. He had given me a really lovely bottle of champagne. And it reflected where he thought our relationship was. It wasn't a proposal.

Mike: It was a question of maturity. I just wasn't ready. But when we remet, there was no hesitation. This was the woman I wanted to live with. Always.

Karen: It was two years later, and it was a very, very sunny day. I had already mourned the loss of the relationship. I was working. It was a Friday afternoon. I went downstairs and crossed the street, and there was Michael.

Mike: I was walking down Park Avenue—

Karen: Third Avenue.

(continues)

Uptown

Mike: Oh, you're right, Third Avenue.

Karen: We sound like an old married couple!

Mike: I was with two colleagues. And walking toward me was this vision of beauty—

Karen: You just want to get lucky tonight, don't you?

Mike: —and we fell into a kiss. We didn't say a word after not having seen each other for two years.

Karen: Without conversation. Thinking about it, I can't even explain it. Except that we literally fell into each other's arms without saying a word.

Mike: My colleagues were obviously aghast. And we haven't been separated since.

Karen: And we've been married for thirty-seven years now.

What's the secret to thirty-seven years together?

Karen: In all love stories, you fall out of love, and you fall in love; it's a constant process as you grow and change through life. There's just nobody else I want to spend my life with. That's the bottom line.

When couples are together for a long time, sometimes they fight. What advice would you give about fighting or conflict resolution?

Mike: Well, it's true that couples do fight. But we also know during the fight that our love for each other isn't in danger. Candidly, the resolution doesn't always come quickly.

Karen: There are times when I've just said, "I'm going for a walk," to really process and think. Like, see ya, bye, I'm out of here.

Mike, if she had an online dating profile, what would it say?

Mike: Someone who has beautiful eyes and a very sensual side.

Karen: Uh-oh!

What would his profile say?

Karen: Golden bachelor.

Mike: Right.

Karen: Seeks sensual companion.

Mike: Golden but tarnished.

Karen: Only slightly tarnished.

John & Sherry

"From Enemies to Lovers"

Can you tell us the story of how you first met?

John: We met in college. She was a freshman and I was a junior. We actually started off kind of hating each other.

Sherry: Yeah, we were practically enemies.

John: Then we had a sit-down. We just wanted to talk through our differences. But the sit-down went on for about nine hours straight. Once we started to chat, we found that we had common interests and values. Time really flew by, because after nine hours, we realized it was three or four in the morning, and that was that.

SoHo

Joey & Celine
"More Than Brunch"

Can you tell us the story of how you first met?

Joey: We met in our early twenties. We'd go to these brunch parties together, and I was dating someone at the time, but she had a crush on me.

Celine: And then they broke up. And we tried dating a few times, but it didn't work out. Then he moved to Chicago, and I thought we'd never see each other again. But he came back, and we ran into each other where I worked. We got together, and now we live in Chicago. We've been together for three and a half years.

Joey: And we recently got engaged, and we're getting married.

What's your favorite thing about him?

Celine: He's smart, and he's driven, and he's talented, and I love how creative he is.

What's your favorite thing about her?

Joey: Her veracity, and she's very loyal, and passionate. I'm really attracted to that.

Williamsburg

River & Peter

"Each Other's Safety"

Can you tell us the story of how you first met?

River: We actually met in a cult. We were both sent to a conversion therapy camp in Texas when we were eighteen. We met there, and—

Peter: We were best friends.

River: We were just best friends for a while. Then during the pandemic—

Peter: We fell in love.

River: We fell in love.

What was it like meeting in that setting?

Peter: I was trying to be the comic relief.

River: My father's a pastor, so I was trying to be straight. And Peter was the one telling me that I wasn't.

Peter: [*Chuckles*] I knew he was gay.

What are your favorite things about each other?

River: His heart and the way that he cares about people in the world.

Peter: I love his compassion for people. He's patient with me. He makes me laugh, and he makes me feel comfortable and safe. He's my home.

What advice would you give to a new couple?

Peter: Listen. Be patient. I think love is the biggest win, honestly. If you have love, you have admiration and respect for your partner, and you're willing to go through anything.

SoHo

Cassie & Carlos
"Comforting and Comfortable"

Can you tell us the story of how you first met?

Cassie: We met in high school. He was a friend of my cousin's. I didn't know anyone else in school except her. She introduced me to her friends. The first thing he did was hug me, which I thought was weird. We didn't actually start dating until like two years after that. We ended up breaking up at the end of high school. After a few years, we reconnected, and we've been together for about six years now.

What's your favorite thing about her?

Carlos: The comforting feeling I have around her. Around most people, there's a slight discomfort—like some social anxiety or something. But with her, that's nonexistent. There's no feeling of judgment or anything. I don't know. It's just fun, good to be with her.

What's your favorite thing about him?

Cassie: His sense of humor and the fact that I never really get tired of talking to him. I have the social battery thing with a bunch of people—I just get drained after a couple hours, but I've never experienced that with him. He always keeps everything light and humorous, which I really enjoy.

Williamsburg

David & Michelle
"Alone Time"

Can you tell us the story of how you first met?

Michelle: We first met about ten years ago. And then about six months ago, we remet. I was riding the bus after work, and he rolled up, recognized me, and said, "Hey, what's up?" We've been hanging out ever since.

What's your favorite thing about hanging out with him?

Michelle: He has really good taste in food and is always spoiling me with delicious food and drinks and pleasures.

What's your favorite thing about hanging out with her?

David: Getting her all to myself.

What are you two most excited for in the future?

David: More alone time.

Michelle: Figuring out how to hang with all my friends! [*Laughs*]

Williamsburg

BARS AND CLUBS

These days, with online dating, it might seem like people don't meet in bars and clubs as often as they used to. But back in the day, it was *the* way it was done. And that's often still the case around the world. Or down at the corner dive. In fact, nightlife brings plenty of couples together. Who'd have thought it?

Sage & Katie
"The Thing"

Can you tell us the story of how you first met?

Katie: We met on the apps, but we had a really stupid first date. Worst bar. Fluorescent lighting, and only seventy-year-old men sitting in there.

Sage: No music.

Katie: I was late, so I rushed in, and I thought, "No way she's sitting at this creepy bar." And then I turned and saw her, and I knew: "That's my wife."

Sage: I was just sitting with all the barflies. These old men, talking to them.

Katie: They said, "Oh, you brought your friend as backup on your date?" They thought she was straight.

Sage: And I said, "No, this is the thing."

Katie: And then I said, "Yes, I'm the thing." For our anniversary, she got me this ring I'm wearing that's engraved with "The Thing."

What's your favorite thing about her?

Katie: Oh my God, she lights up any room she walks into. I'm so proud to bring her anywhere, knowing that she's going to make us friends as a couple. We're both super-extroverted and social people. I'm always confident that any situation will be better, just by her being there.

What's your favorite thing about her?

Sage: Her face. I love her face so much.

Washington Square Park

Olga & Dmytro
"Support System"

Can you tell us the story of how you first met?

Dmytro: We are together since 2014. We are both from Ukraine. We moved here in 2019. We met in a nightclub. My friends took me out to meet girls. I asked Olga, "Maybe can you join us?" and she said no. I told her she pretty much tore my heart out. Then I found her on social media, and I thought, "Okay. Maybe we could do this. Get some coffee." Now we are married for two years and we've been together for almost eleven.

What's your favorite thing about him?

Olga: Just him—how he loves me, supports me, and has been with me all this time.

What's your favorite thing about her?

Dmytro: She is my perfect match, my wife, my everything. She's my main fan and supporter. It feels like you find the person who, at the same time, is your spouse and your best friend.

What are you most excited for in the future?

Dmytro: We are planning to start a family.

Olga: Wow.

Dmytro: [*Laughs*] She didn't know that.

Washington Square

Michael & Julie
"Together on a Bench"

Can you tell us the story of how you first met?
Julie: We met at a club in DC. He was friends with a bunch of my friends, and we started talking. He was dancing with somebody else, caught my eye.

What was your first impression of her?
Michael: Oh, I thought she was beautiful. I was looking at her for a while. I'm not usually the type of person to go up to someone in a bar, because I don't want to talk to anyone. But we just talked the rest of the night. It was probably about a year ago.

One year in, what's your favorite thing about him?
Julie: He's a genuine person. He's really sweet. There's like no bullshit with him. I really like that I've always been able to just be myself around him, and I don't have to put something on.

What's your favorite thing about her?
Michael: She goes out of her way to help me out. I'm still in school—I'm a med student—and I'm not really making money. She always asks how I'm doing. She makes dinner for me. She'll pick me up. I have a lot of ups and downs in school, and she's always encouraging me. I really appreciate it.

What are you two most excited for in the future?
Julie: I'm excited for him to finish med school, so we can just see each other more. [*Chuckles*]

Michael: I want to travel with her—to Europe, to Southeast Asia. I'm always sending her stuff on Instagram of all these fun trips we'll go on.

Williamsburg

Robb & Nora

"A Real Knockout"

Can you tell us the story of how you first met?

Robb: We met at a pub called Drom Taberna in Toronto, and it was a magical first date.

What was your first impression of her?

Robb: Knockout.

What was your first impression of him?

Nora: Knockout.

What happened at the bar?

Nora: We listened to music.

Robb: We went ten rounds.

Nora: [*Laughs*]

How long ago was this?

Robb: A little over three months.

What's your favorite thing about him?

Nora: Everything.

What's your favorite thing about her?

Robb: Her big heart.

What are you most excited for in the future?

Nora: Surviving. Being together and being alive.

West Village

Jess & Kendall
"California Dreaming"

Can you tell us the story of how you first met?
Kendall: We met at a bar, Tenants of the Trees, in Silver Lake, Los Angeles.

How long ago was that?
Kendall: It's been, what, almost seven years now?

Jess: Yeah.

What was your first impression of him?
Jess: I thought he was really cute.

What was your first impression of her?
Kendall: Same thing, honestly. Thought she was gorgeous. Caught my eye on the dance floor and I asked her if she wanted to dance.

Seven years in, what's your favorite thing about him?
Jess: He is the most easygoing, understanding person I've ever met.

What's your favorite thing about her?
Kendall: She always makes me feel really comfortable. And just overall she is a great woman.

What's the secret to seven years together?
Jess: I don't know. Things are just so easy between us.

Kendall: Yeah, honestly, they are.

What are you most looking forward to in the future?
Jess: Growing old together.

Kendall: Yes, that's it.

SoHo

Luis & Maria
"Five Days In"

Can you tell us the story of how you first met?

Maria: We were at the same club. I was a dancer, and he was a friend of my friend. He liked me and I liked him.

Luis: This was in 2017, 2016. Recently I DM'd her and we started talking and hanging out. Now we're together.

Maria: Yay!

How long have you been dating?

Luis: Dating? Five days.

Maria: Yeah, like really dating, five days. But we've been hanging out together for five, six months.

What's your favorite thing about her?

Luis: The way she brings me peace. I think it's the most important thing in our relationship.

What's your favorite thing about him?

Maria: He treats me like a princess. This is so cool because my dad treats me like a princess, so I need someone that treats me right.

Meatpacking District

Dave & Kris

"Strike"

Can you tell us the story of how you first met?

Kris: We met on a dating app when Dave wasn't out to his friends or family yet. We got drinks and appetizers, and that was supposed to be it.

Dave: Yeah... but then we decided to go bowling.

Kris: [*Laughs*] That's when we ran into some of his friends, so we had to pretend it wasn't a date.

Dave: We spent the night texting each other while the other person bowled so no one would catch on.

Kris: Honestly made it even more fun. We got to know each other through text, in the same room. I'll never forget that night.

Do you remember your first impressions of each other?

Kris: When I first saw him, he looked so nervous—it just melted me. I was nervous, too. I actually thought he was out of my league. But then he smirked at me as he walked up to my car, and I felt everything was gonna be okay. It was this instant calm I hadn't felt in years.

Dave: I don't really remember my first impression. [*Laughs*] But it must've been good because the date kept getting longer.

Kris: We still debate how that night actually ended.

What's your favorite thing about each other?

Kris: The way Dave puts me at ease. He's so patient. He broke down walls I've carried for years.

Dave: Kris is relentless. When he sets his mind to something, it's happening. I've always admired that about him.

📍 *Tompkins Square Park*

What are you most excited for in the future?

Kris: Living life as our true selves. We both spent a long time not fully feeling like that was possible.

Dave: Growing old together. Slowing things down. Just appreciating what we've built.

What's the secret to staying together?

Dave: Understanding each other. We know each other's strengths and weaknesses. It's about working with each other, not against.

Kris: And being honest. Talking, even when it's uncomfortable.

Dave: Yeah, lots of that.

Where to Meet People

Where do couples say are the places and spaces they found one another?*

- ♥ **Dating apps** — **22%**
- ♥ **School** — **18%**
- ♥ **Bars** — **15%**
- ♥ **Parties** — **10%**
- ♥ **Work** — **9%**
- ♥ **Clubs** — **7%**
- ♥ **Buses** — **5%**
- ♥ **Trains** — **3%**
- ♥ **Spiritual events** — **>1%**

- ♥ **Sensuality parties** — >1%
- ♥ **Church** — 1%
- ♥ **Running errands** — 1%
- ♥ **Planes** — 1%
- ♥ **Hot-air balloons** — <1%
- ♥ **Protests** — <1%
- ♥ **Craigslist** — <1%
- ♥ **Staten Island Ferry** — <1%
- ♥ **A reality TV show** — <1%
- ♥ **ER** — <1%
- ♥ **Next door** — <1%

*These are our qualitative findings based on interviewing thousands and thousands of couples on the streets of New York City. Like emotion itself, this data is entirely subjective.

COWORKING

Here's a little secret: People meet and fall in love at work *a lot*. All those boring staff meetings and tedious conference calls? Potential hotbeds of romance! In a way, it makes perfect sense—after all, we spend more time with our coworkers than with just about anyone else. And that familiarity can lead to a deeper connection. Just ask these couples.

Alice & Geoffrey

"Oh, Darling!"

Can you tell us the story of how you first met?

Alice: We met at Channel 13. I was an assistant on a very famous series called *An American Family*.

Geoffrey: I was her mail clerk. She was very pretentious, and she ordered every fashion magazine. I had a full cart for delivering all her magazines every day. I dumped a pile of them on her desk one day and she was on the phone going, "Oh, darling, I was just in Morocco. The death in Morocco, darling." I thought, "What a pretentious…" and as I walked away, I said, "*Oh*, the *death* in *Morocco*." And she ran after me, and she jumped on my back and began screaming, "Who the fuck do you think you are?" That was the beginning.

Alice: And then the second part: The family featured on *An American Family* was going on *The Dick Cavett Show*, which was then the top talk show at night. And they invited everyone who had worked on the show to be in the audience. I had two tickets, but no one wanted to go with me. I had no idea why. And finally, in total desperation, guess who I asked?

Geoffrey: I was her absolute last choice for a plus-one. So the show was very contentious and when we came out, we were like, "What was that all about?" And we started talking and walking home. Coincidentally, I had recently moved just down the block from her in the Village. We walked all the way from 57th Street to 11th Street—about two and a half miles. And we were engaged all the way. I remember hitting Abingdon Square, which is the little park near the block we lived on, and thinking, "Jesus, we have just been talking away." I don't think I had met anybody that I could talk to without any inhibition before. I was thinking, "This is unusual. This is good." We started talking and have never stopped. That was fifty years ago.

(continues)

📍 West Village

What's the secret to fifty years together?

Alice: Fucking and fighting.

Geoffrey: Fucking and fighting is a good one. Oh, and roast chicken.

Alice: Oh no, that's not it.

[*Alice and Geoffrey both laugh.*]

Geoffrey: *Your* roast chicken.

Alice: It's luck, along with everything else.

What's your favorite thing about her?

Geoffrey: Her fucking attitude, I think—to life and to me.

What's your favorite thing about him?

Alice: I like Geoffrey. It's much harder to like a person than to love a person. If you like them, like stays. You can love the biggest bastard on wheels. But I like him and like is more important than love.

Fifty years is a lot of life. What are some things you've done together or been through together?

Geoffrey: We were both actors. Once, a playwright wrote a play for us. It was an S&M sex farce called *Louisiana Bound* (which was his projection—we're pretty vanilla when it comes to sex). But it was popular around town. Then I turned to playwriting. And Alice became a writer; she's published two books.

Alice: We were known both off-Broadway and on Fire Island. Every summer, shows were done on Fire Island, serious musicals with costumes, and we were in those shows together.

Geoffrey: Fire Island was huge for us. We lived in the gay community out there for thirty years, because that's where a lot of our theater family was. But in the early 1980s, AIDS began to spread in the US. All our friends, all our colleagues—everybody was dying.

Alice: I began to keep a special death diary of all the memorial services. We went to about seventy. Can you imagine seventy memorial services in seventy churches, or theaters? It was heartbreaking.

Geoffrey: I became the director of communications for the Gay Men's Health Crisis at the height of the AIDS epidemic. The AIDS crisis was a defining, life-changing moment for us. I left theater; Alice volunteered for the GMHC. We were working together to fight AIDS as much as we could. We started one of the first grief groups. It helped us, too, with our own grief.

Alice: I was just so angry at this disease. You couldn't get over the sorrow.

Geoffrey: That's actually what led to us getting married. One of my best friends was sick and it was too late for him to use the AIDS "cocktails." He said, "Look, would you two just get married? Would you please do something fun for us?" Alice was the one who hadn't wanted to get married. I'd asked her all along, and she'd said no, no. But then Alice proposed to me. On Christmas Eve, on Fire Island, and I jumped up and down and said yes.

Alice: A friend in the costume department of the opera house made my dress. I remembered the ending of *Funny Face*, from the early 1960s, with Audrey Hepburn and Fred Astaire, and she has this incredible dress. And I said, "Can we duplicate that dress? So when I walk down the aisle, every gay guy in the house will gasp!" It was a huge wedding, and I think we made people very happy. And because we had a professional photographer, I have that documented in two albums. And my God, it's helpful.

Geoffrey: A lot of the guys were able to be at the wedding with us and celebrate with us… yeah, it was great. And we discovered that marriage didn't screw up our relationship, which we had been afraid it would—because we were ex-hippies, and who needs it?

Kaelanni & Isaiah
"The Real Deal"

Can you tell us the story of how you first met?
Kaelanni: We met at work.

What kind of place were you working at?
Kaelanni: We worked at the RealReal.

What was your first impression of him?
Kaelanni: I thought he was cute. But I didn't pay much attention to him. He was very persistent.

What was your first impression of her?
Isaiah: She scared me.

What's your favorite thing about him?
Kaelanni: He's the kindest person I've ever met. It freaks me out a bit; he's just so generous and thoughtful.

What's your favorite thing about her?
Isaiah: She listens to me. She's very caring. She made me open up very easily.

SoHo

Jasmine & Jacques

"Business Travel"

Can you tell us the story of how you first met?

Jacques: We were on a business trip. We worked for the same company, in different departments. I had my eye on her but didn't know how to approach her. One day I asked her for her Instagram contact, and we connected through there. We've been together two years now.

What's your favorite thing about him?

Jasmine: His patience with me—he's very patient. His softness. His gratitude. He's very loving—that's probably what won my heart.

What are you two most excited for in the future?

Jasmine: A family. And growing our business together.

Jacques: Settling down, advancing into the slow life. Having a family and then having slow mornings, family trips, more quality time together—those are the things that I see.

SoHo

Stanley & Lorraine
"Run Away with Me"

Can you tell us the story of how you first met?

Stanley: We were school principals. And then I divorced my wife and ran off with her because she's so fucking beautiful.

Really?

Lorraine: Yes, at the same time. I was at one school, he was at another.

Stanley: We were the best-looking ones. But she's smarter than me.

Lorraine: After he divorced his wife, we hooked up.

Stanley: Then she wanted to move to Manhattan, so I dropped everything and moved to Manhattan. And oh my God, what a life.

How long have you been together?

Lorraine: Eight years.

What's your favorite thing about him?

Lorraine: He's fanciful and he's happy.

What's your favorite thing about her?

Lorraine: Something with substance, please.

Stanley: She makes me better. A better man.

What are you looking forward to in the future?

Stanley: We're moving back to California because the winters here are too tough. Other than that, getting old with her.

Lorraine: No! You're going to work for the Giants and the 'Niners!

Flatiron

Brianna & Brendon

"The Evolution of Us"

Can you tell us the story of how you first met?

Brianna: We met at work, at H&M.

How long ago was this?

Brendon: Almost ten years.

How'd you go from working together to dating?

Brianna: I was very persistent. I saw him, I thought he was really cute, and I kept going after him.

Brendon: I was a little fatigued from serial dating, so I didn't make it easy.

Brianna: Yeah, he swerved me for a long time. I really liked him, so I kept trying. We were talking for a long time. We started off as friends, and then that led to more.

What was it like working together and dating?

Brendon: It wasn't too bad. The positions were completely separate, so we didn't work side by side.

What's your favorite thing about him?

Brianna: My favorite thing about him is his patience. He's very patient with me, because I can be a lot sometimes.

Brendon: For me, it's her optimism. She's always looking on the bright side, saying, "The best is going to happen. Don't worry."

What are you two most excited for in the future?

Brianna: I want to marry him. To have a future together, travel together.

Brendon: The evolution of us.

Williamsburg

Drew & CiCi

"The Whole Package"

Can you tell us the story of how you first met?

Drew: We were coworkers. I was a server; she was a host. We've dated for a year and a half now.

How'd you go from working together to dating?

CiCi: I needed a male model for a shoot I was doing. I was also modeling in it. My best friend's a photographer. Drew approached me at work and said, "Hey, I want to be in it."

Drew: It was my passive way of saying, "I want to hang out with you." It was a perfect opportunity to get to know her.

CiCi: My best friend always says that she has the image of us falling in love. There's a picture where our chemistry just came through.

What's your favorite thing about her?

Drew: She's so consistent, in terms of energy and headspace. You don't have to guess what mood she's in. Oh, the sun's out; she's in a good mood. I crave that in any relationship.

What's your favorite thing about him?

CiCi: I feel like he holds the entirety of me better than anyone I've ever met. He lets me be myself and lets me grow and struggle, and he is always there for me, which is something I've never experienced before in a partner or in a person. He's just the whole package.

Bed-Stuy

Roberta & Mike
"Summer of '61"

Can you tell us the story of how you first met?
Mike: We met at summer camp. We were both working as camp counselors.

How long ago was that?
Roberta: [*Laughs quietly*]

Mike: Hold on, I'll figure it out. [*Counts on his fingers*] Summer of 1961.

What was your first impression of him?
Roberta: I liked that he was really good with the kids.

Sixty-three years in, what's your favorite thing about him?
Roberta: Oh, not telling you that!

Mike: C'mon. [*Laughs out loud*]

How about telling us the secret to sixty-three years together?
Mike: Let me give you a cliché: Never go to bed angry.

Washington Square Park

Sam & Briana

"Can't Live Without Her"

Can you tell us the story of how you first met?

Briana: We met at work. We started at the same company on the same day. We were in orientation class together.

Sam: She actually hated me on the first day.

Briana: He was more popular than me, so I didn't like him. And he had a girlfriend at the time, so we were just friends. Then a year later, he broke up with his girlfriend and we started dating.

What's your favorite thing about her?

Sam: She makes me feel like I'm at home. That's not something you find every day. Honestly, at this point, I can't imagine living without her.

What's your favorite thing about him?

Briana: How caring he is, with his friends, with our families. He's always there for me when I need him, very supportive.

What's the secret to four years together?

Briana: Instead of you versus each other, it's you versus the problem.

Sam: Yes. That's not something that I think we're perfect at, but we're getting better at it every day. [*To Briana*] You taught me that, actually.

Briana: I did.

The High Line

Devin & Leslee
"Besties"

Can you tell us the story of how you first met?

Leslee: We lived in Vallejo, California, and we worked at Wingstop together. There weren't many places to go in our small town, so we'd hang out at Target.

How long ago was this?

Devin: Four years.

Leslee: It feels like longer. I think because we were friends for about a year before we started dating.

How'd you go from being friends to dating?

Leslee: We lived close to each other, so we were always going out together anyway. It didn't feel like that big of a difference. We're just besties.

SoHo

Edward & Marina
"Not an Asshole"

Can you tell us the story of how you first met?
Edward: We met at work. At a government job.

How long ago was this?
Marina: Five years.

How'd you go from working together to dating?
Edward: Just conversation, talking. We found things we connected on.

What was your first impression of him?
Marina: Can I cuss?

Sure.
Marina: I thought he was an asshole.

Edward: But I thought she was all right.

Marina: Yeah, I at first thought he was an ass, but I found out he was a very intelligent person. I made lot of connections with him that I haven't made with other people in this world. It brought us together. Life just brought us together from afar.

What was it that changed your mind about him?
Marina: Just actually listening to him talk. He made sense. He has a way with words. He can explain things that otherwise I wouldn't understand.

What's your favorite thing about her?
Edward: Her personality. She's happy all the time. At least she tries to be. She's very empathetic and caring.

What's your favorite thing about him?
Marina: His intelligence. Because whatever I don't know, he does.

SoHo

Emily & Eric

"Love Is in the Air"

Can you tell us the story of how you first met?

Eric: We both worked for the New York City Housing Authority. We met there and fell in love. That was like eleven years ago.

How'd you go from working together to falling in love?

Emily: Immediately.

Eric: We just vibed. It clicked. Within a couple of months, we were living together.

What was your first impression of him at the office?

Emily: Very friendly. Very authentic. Very real. Very approachable. Maybe a little bit older than me? But we're actually the same age.

What was your first impression of her?

Eric: Super scrappy. Incredibly active and energetic, very outspoken and confident. I liked the juxtaposition of a big strong personality in such a tiny package.

What's your favorite thing about him?

Emily: His heart. He's very charismatic. He loves everybody equally, honestly. His love goes to everyone. It's sometimes the most annoying thing and it's also the best thing. I benefit from it all the time. I should probably add that I am pregnant. There's a lot of love in the air these days.

What are you two most excited for in the future?

Eric: Being parents. It's terrifying, but it's super exciting. She's got this ability to see the opportunity for play and joy and exploration anywhere she goes. I'm super excited to raise a kid with this mentality that the world is a place to play and discover.

SoHo

Marietta & Tony
"It Should Be Easy"

Can you tell us the story of how you first met?

Marietta: We met in an engineering lab. I graduated college and started working at the same company as Tony. I worked with him in the lab. Tony was my mentor.

How long ago was this?

Tony: 1985.

Marietta: Oh, wow. Almost forty years. Oh, no. Wow.

What was your first impression of him?

Marietta: He was the nicest person I'd ever met. He was very patient trying to teach me how to use the equipment.

Tony: I told my friend, "Well, this great woman is starting to work for us, but I'm going to keep it very professional because I've got to be professional at work." Then three days later, I asked her to come out to lunch with me, and then we went from there.

What are you two most excited for in the future?

Tony: Grandkids.

Marietta: Grandchildren. Well, not yet, but we have a son who just got married and a daughter who will be married soon, so probably grandchildren. Something to look forward to.

What advice do you have for a couple that just met?

Marietta: It should be easy. People always tell you it's hard. It should be easy. If it's not easy, it may not be the right match.

Tony: And you've got to laugh.

Marietta: Oh, definitely. You've got to laugh every day. He has a lot for me to laugh about.

Tony: Yes. I give a lot of good material.

SoHo

The Secret to Staying Together

What do couples say is the number one thing that connects them?*

- ♥ **Communication** — 40%
- ♥ **Listening** — 18%
- ♥ **Sense of humor** — 9%
- ♥ **Kindness** — 6%
- ♥ **Shared interests** — 6%
- ♥ **Family** — 4%
- ♥ **Boundaries/space** — 4%
- ♥ **Sex** — 3%

♥ **Optimism/pessimism**	**2%**
♥ **Culture and religion**	**2%**
♥ **Seeing/being seen**	**2%**
♥ **Music and the arts**	**2%**
♥ **Cooking**	**1%**
♥ **Separate beds**	**<1%**
♥ **Distance**	**<1%**

*These are our qualitative findings on the nature of love, based on interviewing thousands and thousands of couples on the streets of New York City. Like emotion itself, this data is entirely subjective.

MUSIC

From DJing to singing, concerts to open mics, drums to guitars, music brings couples together. All kinds of people, places, venues, and styles unite folks to make beautiful music together, both literally and—ahem—figuratively. It's a common interest that can easily spark creative and romantic partnerships.

Eduardo & Maria Eduarda

"A Perfect Match"

Can you tell us the story of how you first met?

Eduardo: I'm a DJ—I'm from Brazil; I play electronic music. So back in the day, 2014, I was playing for the very first time, and I met her.

What's your favorite thing about her?

Eduardo: I love her. She has the most beautiful heart. She loves me with all her heart, and for me, it's a perfect match. You look around at other people, but when you find the one.... She is the one for me. I love her so much. She's going to cry.

Maria Eduarda: I'm crying.

What's your favorite thing about him?

Maria Eduarda: He's my favorite person in the world.

Eduardo: And I love you.

What are you most excited for in the future?

Maria Eduarda: Familia.

Eduardo: Our family, to have our house, to travel around the world and do fun things and help people. This kind of stuff is what we are chasing.

SoHo

Andi & Kat

"Just Looking at Her"

Can you tell us the story of how you first met?

Andi: I was living in Bushwick a few years ago and she was my roommate's coworker. He told us that he'd just met someone at work who was a DJ, and he was trying to learn how to DJ, so he started inviting her over to give him lessons. Then one night she came over and she was DJing and performing, doing a whole set. And I remember just looking at her. I had never been interested in girls at all. And I thought, "Wow, what is happening to me right now?" We went on our first date. She said, "I love you." We moved in together.

Kat: Not on the first date. Not on the first date.

Andi: Like three days later! Now we've been living together for three years.

What was your first impression of her?

Kat: That she was the most beautiful girl I'd ever seen. She came upstairs from her basement room, having just woken up, wearing an oversized navy shirt, to get something from the fridge. That's what I thought.

What's your favorite thing about her?

Andi: The way that she effortlessly makes me laugh. It's never-ending.

Kat: I was going to say the same.

What are you most excited for in the future?

Kat: Wherever we go next, we'll always have each other.

Williamsburg

Amy & David
"Excited for Every Day"

Can you tell us the story of how you first met?

Amy: I'm a recording artist and my husband's a guitarist. We met a long-ass time ago when I was in another band and I was the lead singer. He was writing for a music blog, and he was in the audience that night. And that's how it happened.

What was your first impression of her?

David: I'd never seen anyone so gorgeous.

How long ago was this?

Amy: Twenty years ago.

Twenty years in, what's your favorite thing about her?

David: Ah. She's my best friend.

What's your favorite thing about him?

Amy: His intellect, his sense of humor, his incredible quirkiness, and he's my best friend. Also, he's an incredible lover.

What are you most excited for in the future?

Amy: Oh, every single day. You've got to be excited for every day. Treat every day like you're excited for it, regardless of what's going on in the world or your life, because you can't make anything else better if you don't start from within.

Williamsburg

Yonel & MJ

"Float Your Boat"

Can you tell us the story of how you first met?

MJ: We met at a DJ set on a boat. I was with some friends. He was with some friends. And then my friend ended up knowing his friends, from Atlanta. We all hung out that night, but I was really cranky because I was hungry and there was no food on the boat. I didn't talk much, so I think his first impression of me was that I was, what, stuck-up?

Yonel: Yeah.

MJ: We hung out a lot that weekend, but it was strictly platonic. Then we reconnected a few months later, and we ended up hanging out with a bunch of friends again. And the two of us were the last ones left at the end of the night.

Yonel: And one thing led to another.

MJ: Yeah, and now we're together, engaged with a baby. We're actually going to pick her up from school right now, and we just voted.

How long have you been together now?

Yonel: Three years.

What's your favorite thing about her?

Yonel: Her positive energy. I feel like she wakes up every day in a really good mood. She gives me a lot of energy.

What's your favorite thing about him?

MJ: Everything. He would hate that I would say his booty! But if I were going to say something about his personality, it would be that he just makes me so happy, and he makes me feel so loved and heard. It's the quality time and the effort he puts into taking care of me and our daughter. He's my best friend. I love him so much.

📍 *Prospect Heights*

Sarah & Paul
"Continue the Conversation"

Can you tell us the story of how you first met?

Sarah: My friends took me to hear his band, and we chatted on the dance floor. Then we decided to continue the conversation.

Paul: That's exactly it.

How long ago was this?

Paul: About a year.

What's your favorite thing about him?

Sarah: Everything.

Paul: Me, too.

What's your favorite thing about her?

Paul: She's just unbelievably sweet and understanding.

What's your favorite thing to do together?

Sarah: Last night we went to *La Bohème*, and that was pretty much off the hook.

What are you two most excited for in the future?

Sarah: Well, to eat the wings that we just got!

Paul: Yes. And for peace in our lives—

Sarah: Yes.

Paul: —and hopefully a little more peace in the world, but I'm sixty-three and I ain't holding my breath.

SoHo

Josiah & Danielle

"My Rock, My Roll"

Can you tell us the story of how you first met?

Josiah: We met in 2023, through music.

Danielle: I needed a drummer. He's a drummer and is also in a band.

What's your favorite thing about each other?

Danielle: I could say so many things. He's one of the most talented people I've ever fucking met. I always say I'm a fan first. I love watching him work. He's incredibly generous as an artist.

Josiah: My favorite thing about them is how they balance out my existence and my energy. They're my rock. They keep my roots in the ground. And their compassion, their empathy for people in the world and everyone they love and might not love.

What are you most excited for in the future?

Danielle: Making more music together.

Josiah: Possibility and creativity.

What's your favorite band to listen to together?

Josiah: Together? Probably an artist over a band. Want to do three, two, one?

Danielle: No. What if we get it wrong?

Josiah: Then it'll be good content.

Danielle: Okay, ready?

Danielle and Josiah: Three, two, one: Frank Ocean.

SoHo

Nev & Kelley

"365 Smiles"

Can you tell us the story of how you first met?

Nev: We met at an open mic in Harlem. She was helping host it. My friend randomly sent me there because I'm a singer. I had called him and said, "Hey, I just got off work and I need a place to go." I show up, and she's one of the first people I meet.

Kelley: He was mad early. [*Laughs*]

How long ago was this?

Kelley: A year ago.

What was your first impression of him?

Kelley: [*Chuckles*] I thought he had a beautiful voice and amazing style.

What was your first impression of her?

Nev: She was extremely hot. [*Laughter*] I walked in, I clocked her, I was like, "Okay, well, you're cute. I'm going to talk to you at some point. I don't know when." I didn't think that we would be in a relationship. But I definitely wanted to know who she was.

What are you most excited for in the future?

Kelley: I'm excited to see what cool shit we do together this year.

Nev: I'm excited to see how many ways I can make her smile.

Upper East Side

FAMILY TIES

You might think meeting a partner through family is old-fashioned, but it actually happens just as often today as it ever did. You go to a family barbecue, you help your sister move a piece of furniture, you meet your cousin's best friend, you attend a family wedding. The next thing you know, you've met the love of your life.

Peter & Joyce
"Kind of Arranged"

Can you tell us the story of how you first met?

Joyce: We met through friends and family in Montreal. It was kind of arranged. We liked each other. I told him what I wanted in my life, and he told me what he wanted in his. We felt we could meet each other's needs, and we decided to get married. We got married in Montreal three months later. Then we came to the States. We have three children. We have six grandchildren. We've worked, and we've been very successful in life. Thank God.

What was your first impression of him?

Joyce: I was young when I met him, and right away, he bought me a beautiful gold necklace. I was a little shocked, and I didn't want to accept it. I said, "Oh, no, it's too good." He said, "No, I bought it for you. Even if you don't marry me, that's okay. I bought it for you, and it's yours."

What was your first impression of her?

Peter: That I found a very good girl. Everything good is with her. Family, kids. That's what I wanted.

How many years ago did you meet?

Joyce: Fifty-four.

Fifty-four years in, what's your favorite thing about him?

Joyce: He lets me be me. [*Chuckles*]

📍 *Long Island City*

What's your favorite thing about her?

Peter: She's an excellent cook. [*Laughs*] She does a lot of good things. We're in a beautiful family.

What's the secret to more than half a century together?

Joyce: You've got to give 100 percent. If everybody gives 100 percent, and nobody's entitled, that's the secret.

Wilfredo & Michelle

"Hey, Beautiful"

Can you tell us the story of how you first met?

Wilfredo: We met in high school. My cousin was her best friend.

Michelle: Yeah, and Willie DM'd me—or, well, inboxed me—on Facebook, in 2012. He said, "Hey, beautiful." We've been together ever since.

Twelve years in, what's your favorite thing about him?

Michelle: I like that we can joke around and have our insiders and just chill out together.

What's your favorite thing about her?

Wilfredo: I love her hair. And I love her personality. She makes me a better person every day.

What's your favorite thing to do as a couple?

Michelle: Probably go to garage sales and find cool things.

What are you most excited for in the future?

Wilfredo: We just got married in September, so we're excited to start a family. Get a house.

Michelle: Travel to Japan.

SoHo

Ashley & Joshua
"Play That Music"

Can you tell us the story of how you first met?

Joshua: We met at church.

Ashley: No, we didn't meet at church. We met at my brother's Fourth of July barbecue. Joshua had his eyes on me. I didn't have my eyes on him. Then we had our *second* meetup at church.

How long ago was this?

Ashley: 2016, and we got married in 2020.

What happened at church? You met there a second time, you said?

Ashley: Yes. Our sister—our sister in Christ—invited me to the church because she wanted me to have my eyes on him. He's a musician, and he was playing the organ.

Joshua: I think she just invited you to church to come to church.

Ashley: No, she had a plan. She'll tell you that she had a plan. He was on that organ, and I thought, "There's something about that music."

Joshua: My goodness.

What's your favorite thing about him?

Ashley: He is funny as hell. He makes me laugh like nobody else. He should definitely be a comedian.

Joshua: Part-time.

Ashley: He's my personal comedian.

Bed-Stuy

What's your favorite thing about her?

Joshua: Her genuineness. It's across the board. Loving what she does as a profession—she's a social worker. Her love for children and people was something that attracted me to her.

What advice would you give to a new couple that just met?

Ashley: Be transparent. Be consistent with the transparency. *Actively* communicate. Everybody says how important communication is, but the biggest part of communication is comprehension. You've got to be able to understand what's being delivered to you.

Joshua: Yes, and listen to your partner. Never stop dating one another. Keep it fun. You have to be super intentional about dating each other.

Domingo & Fernanda

"Danced All Night"

Can you tell us the story of how you first met?

Fernanda: There are two stories. The first one is: He was a friend of my sister. I was supposed to meet him in Paris, but then I saw his picture and I thought he was not that handsome, so we never met.

Domingo: I was living in Paris.

Fernanda: The second one is—you tell it.

Domingo: At your sister's wedding.

Fernanda: At my sister's wedding. And we danced all night.

Domingo: Ten years ago.

What's your favorite thing about her?

Domingo: She really works to make her dreams come true, to make it real.

Fernanda: Yes, and I love his mind because he always makes me laugh and he's always creative and he always has ideas, so he's always creating something.

What are you most looking forward to in the future?

Domingo: Staying together.

Fernanda: Forever.

Domingo: Yes, and having some nice trips together.

Fernanda: Everything together, yes.

Domingo: Being happy.

Fernanda: Being happy.

SoHo

Missy & Lorenzo
"Easy Breezy"

Can you tell us the story of how you first met?

Missy: We were vacationing in Sydney.

Lorenzo: I was there with my family. My cousin was her best friend. The rest is history.

How long ago was this?

Lorenzo: Six years ago.

What was your first impression of him?

Missy: He was a kid. He was my best friend's younger cousin.

Lorenzo: Yeah, I'm six years younger than Missy…

What's your favorite thing about him?

Missy: He's so easy to be with. I never doubt his intentions with me. We're married now.

Lorenzo: She makes life easy. I come home from work, nothing to worry about. It's simple.

McCarren Park

Caleb & Micah
"Four Coffees"

Can you tell us the story of how you first met?

Caleb: We met when this coffee shop opened around the corner from my work, and she was working there.

Micah: He's a cheesemonger. He came in a lot.

Caleb: I started lingering a lot.

Micah: I was like, "Wait. We have more to talk about than in this one-minute conversation we have each time after I give you your coffee." [*Chuckles*]

How long ago was that?

Micah: Four months ago.

Do you remember what you did on your first date?

Caleb: Yes. First, she invited me to a dance performance of hers. And I went, but that wasn't really a date. I just watched her dance.

Micah: But I was pleased that you came.

Caleb: Then you asked me out.

Micah: I did, yes.

Caleb: We went and sat in Rittenhouse Square Park. We're in Philly.

Micah: We got coffee.

Caleb: Four coffees.

Micah: Four coffees.

Caleb: Then a few drinks. It was like a seven-hour date.

Micah: Yes. It was great.

SoHo

What's your favorite thing about her?

Caleb: I love how you tell me what you're thinking constantly. You're just so yourself.

What's your favorite thing about him?

Micah: He's very genuine. He wears his heart on his sleeve.

What are you two most excited for in the future?

Micah: Many things. The seasons changing.

Caleb: We might move in together. Is that too public? I don't know. Your grandma wouldn't see this. She's not on Instagram like that.

Micah: No, it's fine. I think it's exciting to envision so many possibilities.

ON THE APPS

Of course, in this day and age, the most common way people meet is online. Dating apps rule the scene. Never before have so many people had such an exhaustive (and potentially exhausting) way to find one another. Of course, what's really exciting is what comes after the online connection. More often than not, that seems to involve eating delicious food together. And for a lucky few, finding true love.

Gilad & Chris
"Dance Partners"

Can you tell us the story of how you first met?

Gilad: We met on an app, but we were in two different parts of the country. We just talked and flirted for a couple of years until he came to New York for a weekend. Then we continued to be friends for another seven years. Then after the pandemic, he was living in Atlanta, and I was down there for work, and the timing was right.

How long ago was this?

Gilad: We've known each other for twelve years, been together for three.

Three years in, what's your favorite thing about him?

Gilad: His undying optimism and support.

What's your favorite thing about him?

Chris: His courage in being vulnerable.

What's your favorite thing to do together?

Gilad: Dance.

Chris: Yes. If there's music and a good beat, we dance. We're in our own world. We've got our little five, six, seven, eight count. People are just like, "Dude, what's going on? The club's closing." We're like, "Oh, sorry." We're dancing, enjoying the music, smiling, having a good time. That's our jam.

SoHo

Haymar & Adi
"Pasta Date"

Can you tell us the story of how you first met?

Adi: We met on Hinge. A year and a half ago.

What stood out about his profile?

Haymar: I think it was his eyes. He's really cute. Yeah.

What stood out about her profile?

Adi: She had a prompt on her profile, which was that her pet peeve is guys who want her to look after them. I asked her what that meant, and then I hit her up with this line, saying, "Oh, I think you're probably Forbes Under 40. That's why everyone is asking you to take care of them financially." Then later I found out that—

Haymar: I'm in health care. I'm a nurse.

What did you guys do on your first date?

Haymar: We went out for pasta. Yeah, so that's like our signature date.

Adi: We actually just ate pasta.

What's your favorite thing about him?

Haymar: He's such a cool guy. He's really open-minded about feedback. He communicates really well. I like that about him, and he's kind and nice.

What's your favorite thing about her?

Adi: She has a very tough exterior, but she's soft on the inside; the more I get to know her, the more I find the sweeter and gentler parts of her personality.

What are you two most excited for in the future?

Adi: We're doing long-distance right now, so hopefully that ends soon. At some point, we get to live together. This trip in New York is actually us breaking our LDR for a quick getaway trip.

📍 *SoHo*

Michael & Caitlyn
"Star Power"

Can you tell us the story of how you first met?
Caitlyn: We met on this cute little app called Hinge.

What stood out to you about his profile?
Caitlyn: His artistic photos. And the way he said hi to me—he was really funny, and I liked his personality. He makes me laugh.

How long ago was this?
Michael: Fourteen, fifteen months now.

What's your favorite thing about her?
Michael: I love her goofiness. I love how she has star power, star energy. Anyone she talks to loves her. 'Cause she's just so supportive.

What's your favorite thing about him?
Caitlyn: He's a really good listener. I'm kind of crazy. And he's calm. He's like, "Wait, babe. Let's bring it back." He's very grounded. He balances me out.

Gowanus

Odin & Georgia

"Love at First Bike"

Can you tell us the story of how you first met?

Georgia: We met on the apps, and we went city biking together. That was a big moment.

What was your first impression of his profile?

Georgia: He's cute. He had sort of an outdoorsy feel—and I was like, "That's cool, that's my vibe." I knew we'd have things in common. And we do.

Odin: Outdoorsy vibes were coming from her, so that was good.

How long ago was this?

Georgia: October.

A few months in, what's your favorite thing about her?

Odin: I like how creative she is. And that she does the things she wants to do.

Georgia: He's the sweetest person I've ever met.

What's your favorite thing to do together?

Georgia: We like to make things—craft and paint.

What are you most excited for in the future?

Georgia: We're going skiing together. He's a snowboarder. I'm a skier.

SoHo

Martina & Vince

"On a Rooftop, in the Summertime"

Can you tell us the story of how you first met?

Vince: We met online. I liked her at first glance. We talked a lot about fashion and life. We connected on our backgrounds and everything. It's been three years now.

Do you remember what stood out about her profile?

Vince: It was just an energy. I felt a wholesome kindness, beauty, and love about her.

What did you guys do on your first date?

Martina: It was actually right around here. It was called the Latin Spot, on a rooftop, in the summertime. I was wearing blue.

Vince: It was good. We both had shrimp balls.

Martina: Yeah.

What was your first impression of him?

Martina: I thought he was very shy but so sweet with a calm presence that I loved. I just enjoyed being around him. And he was funny.

What's your favorite thing about her?

Vince: It's a beautiful mixture of someone who knows me—who I think knows me better than I know myself—but, at the same time, is also looking to grow and evolve with me. Someone who's willing to go through the journey together.

What's your favorite thing about him?

Martina: He cares about everybody else. He's an all-around amazing person. He'll go above and beyond for someone. I love that humanitarian aspect of his personality, and how he's just so loving and caring.

Williamsburg

Yasmine & Daniel

"Great Hearted"

Can you tell us the story of how you first met?

Yasmine: We met on the apps seven years ago.

What's your favorite thing about her?

Daniel: There's a lot. She's a great cook. She's hilarious. She's beautiful. She's got a great family. She has a great heart. She cares a lot about our animals.

What's your favorite thing about him?

Yasmine: He's genuine. He's liked by all. He has a very good heart. A kind soul. He's a great person.

What's your favorite thing to do together?

Yasmine: Cooking together.

Daniel: Cooking is great, yes. We cook a lot together. Date nights. Family time.

Williamsburg

Yoshi & Wilbert

"Just Hanging Out"

Can you tell us the story of how you first met?

Wilbert: We met online.

What stood out to you about his profile?

Yoshi: Very cute. Good smile.

What stood out about his profile?

Wilbert: Very fashionable. An interesting person.

What did you do on your first date?

Wilbert: Wait, what did we do? We went to a bar, I think?

Yoshi: We got sushi?

Wilbert: No, we went to a bakery!

Yoshi: Oh, we went to a bakery.

How long ago was this?

Wilbert: Almost a year ago.

What are you most looking forward to in the future?

Wilbert: Oh, I don't know. Just hanging out.

Williamsburg

Tiffany & Stephen
"Comfort Food"

Can you tell us the story of how you first met?

Tiffany: We met on the apps. He lied about his location. He said he was in New York, but he was actually in Philly. I said I don't do long-distance. Then he came here. He's a chef. He cooked me a whole bunch of food for our first date, which was kind of creepy, but nice of him. Then we kept seeing each other. And we make it work.

How long ago was this?

Stephen: It's been four months.

What's your favorite thing about him?

Tiffany: He's sweet and thoughtful, and he makes me feel really safe. We can just be ourselves together.

What's your favorite thing about her?

Stephen: She's really kind. She knows what she wants. She's very good at communicating—it makes everything so much easier.

What's your favorite thing to do together?

Tiffany: Eat.

Stephen: We love to eat.

Tiffany: Trying restaurants.

He's a chef. What's your favorite thing he cooks for you?

Tiffany: He makes really good Korean food. I'm from California, so it brings me back home. He also made this pasta on a whim, with bacon and scallops. It was so good.

📍 *Prospect Heights*

Aijah & Jonathan
"Unrelentingly Kind"

Can you tell us the story of how you first met?

Aijah: We met on the apps. I commented on his skin-care routine and asked what products he uses.

Do you remember what stood out about her profile?

Jonathan: Her smile.

Aijah: Aw.

How long ago was this?

Jonathan: Two years.

What did you do on your first date?

Jonathan: We got sushi. I wasn't a sushi fan, but she was, so we got some.

Aijah: We got a whole sushi boat, and then he broke the news to me that he doesn't really eat sushi, and I was like, "Wow, that's a lot of raw fish for someone to eat."

Jonathan: Now we have sushi probably once a week.

What's your favorite thing about him?

Aijah: His honesty.

What's your favorite thing about her?

Jonathan: She's unrelentingly kind. A very kind person.

What are you two most excited for in the future?

Aijah: Honestly, to see our kids' humor. Because he's hilarious.

Jonathan: I'd say that, and to see what home we live in. Like how it's laid out. I'm curious.

Clinton Hill

Becca & Leo

"Taking Care"

Can you tell us the story of how you first met?

Leo: We met online.

How long ago was that?

Leo and Becca: Four years ago.

What stood out to you about his profile?

Leo: Yes, what did?

Becca: [*Laughs*] I remember he looked so cute. He had glasses; his freckles.

Leo: What can I say?

What stood out about her profile?

Leo: She was cute. Couldn't tell you what her prompt said, but it stuck out to me.

What's your favorite thing about him?

Leo: I know what you're going to say.

Becca: He takes care of me. He cooks for me and makes sure I'm happy, and always makes me smile. He takes good care of our newly adopted dog, too. I can't ask for more.

What's your favorite thing about her?

Leo: Even if I'm having a bad day, she comes home, and the bad day's over. She makes me happy. Just an overall great woman and somebody I would definitely want to spend the rest of my life with.

Becca: Good.

Greenwich Village

Eric & Jordan

"Raise the Stakes"

Can you tell us the story of how you first met?

Jordan: Five years ago, I was in the city for my best friend's birthday party, and we were hungover. I was swiping on the apps and I come across his profile. I was like, "Oh, my God, what a hottie." Then we matched, and I asked him to meet us at the bar because I thought it was low stakes. He said no.

Eric: I was thinking, "No. I'm not going to meet thirty friends at a bar. We just met online."

Jordan: I was like, whatever. "Here's my phone number." If he texts me, he texts me. He texted me for two days. I tried to play it cool. But then he texted me and was like, "This is tripping now." Five years later, we're engaged.

What's your favorite thing about him?

Jordan: Ooh. His honesty. How much he supports me and how much he loves me. What about you?

Eric: Everything about you.

Jordan: As he should.

📍 *SoHo*

Ty & Ivory
"You Don't Have to Ask"

Can you tell us the story of how you first met?

Ty: Yeah! We first met on Instagram. Her friend posted a picture of her, and I was jacked up over it. So I made that reach out. The way she tells it, she bagged me, but I really bagged her because I made that first move. We started talking and had our first date. Our first date was beautiful.

Where was your first date?

Ivory: It was at a Korean barbecue spot.

What was your first impression of him on the date?

Ivory: I'd never gone on a date with somebody through Instagram before, and I didn't know what to think. I figured it's going to be something short-term, but it ended up being long-term. It's been eight months so far.

What was your first impression of her in person?

Ty: I ain't going to lie, she blew my mind. She got comfortable with me, and from there we hit it off.

What's your favorite thing about him?

Ivory: He's there for me when I need him. I just went through something hard—my dog died. He came to my house without me having to ask. And he was there for the whole cremation process and everything.

What's your favorite thing about her?

Ty: She doesn't know it, but she's warming. She'll take care of me without me asking. If I need a back rub, she gives me one. She'll come all the way from her crib to mine and make homecooked food if I don't feel like cooking. She's the best, she is *the* best.

What are you two most excited for in the future?

Ty: Oh, touring the world. We haven't been on a plane yet, so that is about to happen soon.

📍 *Union Square*

Meredith & Chris
"Unlikely Lovers"

Can you tell us the story of how you first met?

Chris: We met on Hinge, strangely enough. Quick and easy.

Meredith: During the second summer of Covid.

Chris: I was living in Brooklyn. She was in Manhattan. It was a weird match. We started talking, liked each other, and kept dating and dating.

Meredith: He's someone I never would have met otherwise. I'm a corporate marketer. He's an artist. We had nothing in common in our daily lives.

Chris: Right. We would never have crossed paths otherwise.

Meredith: When we met, we realized we share a sense of humor and a lot of other things. He spilled beer on me on our first date. We went to a place that serves beer, and neither of us likes beer. I don't know how that worked out. It was in the dead of August. We were sweating bullets. We saw each other again, and we kept seeing each other.

Chris: Then we got married.

Congratulations. You met three years ago?

Chris: Two and a half.

What's your favorite thing about him?

Meredith: A very good friend of mine said to me yesterday that she and her new husband, who has only known me for maybe a year, have noticed how much softer I am, being with Chris. I'm a New Yorker. I was born and raised here, and Chris is a Southerner. We have very opposite ways about us. That's probably one of my favorite things, realizing how much I've been able to relax with him. To not be so intense and hard-edged. Sometimes it's good to be that way, but I was a little overindexed in that before I was with him.

(continues)

📍 West Village

What's your favorite thing about her?

Chris: I absolutely love her laugh, and I love making her laugh. She's also very much an equal partner. This is the healthiest relationship I've ever had. Having somebody that's behind you 100 percent and being behind them 100 percent, it's breathtaking. It's amazing.

What are you most excited for in the future?

Chris: Oh, expanding the family. In the next year or two. That's an adventure neither of us has explored before.

What stood out to you about his profile?

Meredith: I still have a picture of Chris's on my phone. I was on apps in New York for a long time, probably ten years. I've been on many app dates, and I've seen a lot of the same thing. Chris had a picture of himself in a beanie and a T-shirt next to a piece of art. It said on his profile that he worked in an art-adjacent job, but it didn't say that he was an artist. I was intrigued by that. I told him that the rest of his photos were terrible. But that one photo drew me in. His face was so kind and relaxed. He looked like he was in his element, and it was unique compared to other pictures I had seen.

Do you remember what stood out about her profile?

Chris: Her prompts were very straightforward. You could tell she wasn't somebody who was messing around. She wasn't there to spin the wheel.

Meredith: My profile had been optimized.

Chris: Yeah, she had it down to a science. When I first reached out to start a conversation, she was very up front about looking for a potential life partner. That was just refreshing. There was no beating around the bush. It was great.

The Dangers of Our Job

We all have bad days. These are the things that most often ruin ours, and how often they happen.

Motorcycle/siren/shouting/car horns/saxophone ruining a great story	**40%**
Turf wars with charity solicitors/other street filmers	**15%**
Startling a person who's having a bad day and getting yelled at	**15%**
Getting one-word answers to questions	**10%**
Pedestrians walking directly through the middle of a great interview	**8%**
Trying to interview a couple that wouldn't stop walking	**5%**
Stopping a couple that didn't want to be seen together in public (people having affairs, etc.)	**3%**
Getting told a clearly made-up story	**2%**
Couple starting to make out	**<1%**
Couple starting to fight	**<1%**

OUT AND ABOUT

Think about the time you spend out in the world. At the gym, in the park, at community events. Running errands, eating out, even just walking down the street. Many of us are closed off to other people as we move through public spaces. But some, now and then, are open to connection.

Thuy & San
"Off the Wall"

Can you tell us the story of how you first met?

Thuy: We met at a climbing gym. I was visiting from San Francisco. I saw him there. I started climbing, and then he followed on the same wall.

San: I approached nonchalantly and started talking to her, not with any intent to hit on her.

Thuy: Yeah, I don't think he was trying to hit on me.

What was your first impression of him?

Thuy: He looked like a nice guy. [*Laughs*]

San: No, that's not true. You thought I was trying to hit on you.

Thuy: [*More laughter*] You're still a nice guy.

What was your first impression of her?

San: Well, it was during Covid, so we had masks on. But I thought she was super chill.

Thuy: My eyes, right? My eyes were chill.

San: She has really nice eyes. The thing is, she had to fly back to SF. I'm like, all right. Maybe just keep in contact with her. Follow her on Instagram. So I followed her.

Thuy: I didn't follow him back.

San: Yeah. I noticed that she didn't really follow anybody back.

Thuy: Because I thought he was hitting on me, so I didn't follow him back.

San: A few months passed by. A friend from college told me she was going to go climbing.

(continues)

📍 *Clinton Hill*

Thuy: And I know that friend.

San: Yeah, I met up with the friend and she's like, "Oh, this is my friend Thuy." I'm like, "Wait. You're the girl that I met before, just randomly." She's like, "Yes, I just moved to New York." I'm like, "Oh, okay. Interesting."

Thuy: Yeah. Then he started chasing me.

Why did you finally give in?

San: It was a three-month-long pursuit.

Thuy: You know what? Consistency is really valuable. He was very consistent with showing his affection, his interest.

How long have you been dating now?

Thuy: Three years.

What's your favorite thing about him?

Thuy: His consistency. That same thing. Always showing up, being supportive. I think consistency is undervalued. It's so important when a person shows up consistently as themselves. Supporting you, loving you, being loyal, being funny. It's nice to not be surprised.

What's your favorite thing about her?

San: I love her ability to make me do things outside my comfort zone. She's very, very smart. I hate to admit it, but she's usually right. Guys should probably learn from their female counterparts—they're usually right.

Malvin & Britton

"Right Here, Right Now"

Can you tell us the story of how you first met?

Britton: We met on Bedford and Sixth, on the street.

Malvin: Right here.

Really? Right here?

Britton: Literally right here.

Okay. How did you guys meet on the street?

Britton: Tell him, baby.

Malvin: It was a Sunday, like today, and I had gone to get cat food, or cat something, and I was coming from the cat store with my cat litter or whatever. I was walking on that side of the street, and I'm waiting for the light to change to cross, and then—

Britton: —this fine-ass man—

Malvin: —this man bikes, on like a Citi Bike—

Britton: —ugly-ass Citi Bike—

Malvin: —and I turn and see him, and I was like, "Wow, he's gorgeous, beautiful." And I thought, "If he stops, I am going to walk up to him." And then I think he thought the same thing, so he slowed down the bike, and I walked up to him, and—

Britton: —boom.

Malvin: Boom.

What'd you say?

Malvin: I think I said hi.

Britton: Hi?

(continues)

Malvin: Yes.

Britton: Yes, hi.

Malvin: Yes.

What was your first impression of him?

Britton: "Damn, he's fine. Holy shit."

Then what happened from there?

Britton: I went on to the gym. And I prayed. And I was like, "Who the fuck was that guy, what happened, what happened, what happened?" He texted me, he was like, "Hey, where are you?" "I'm at the gym." Then he said, "You want to have lunch?" He took me grocery shopping the first day we met up. We went to his house, made lunch, and didn't fuck.

[*Laughter*]

How long ago was this?

Malvin: Two years.

Two years in, what's your favorite thing about him?

Britton: His patience. I'm a Scorpio, and he lets me be. He's a good one.

What's your favorite thing about him?

Malvin: His soul. He's a beautiful soul.

What's the secret to two years together?

Britton: Not being basic gays.

What are you most excited for in the future?

Britton: Babies. Right?

Malvin: Yes.

Williamsburg

Arleen & Ken
"Warm Milk"

Can you tell us the story of how you first met?
Arleen: I was carrying a parasol on the street, and he stopped me and said, "What a great parasol."

I know this is going to sound crazy, and maybe stupid, but what's a parasol?
Arleen: An umbrella for the sun. I am known for carrying it throughout the city.

What made you stop her?
Ken: Her smile, her eyes, her parasol, and everything that was underneath. [*Laughter*] I'm not going any further.

What was your first impression of him?
Arleen: He was pleasant, nice, friendly. Because I'm very friendly, obviously.

Ken: Pleasant? That makes me sound like warm milk.

[*Laughter*]

How long ago was this?
Ken: Six months.

What's your favorite thing about him?
Arleen: His sensitivity and kindness.

What's your favorite thing about her?
Ken: Her quirkiness.

What's your favorite thing to do together?
Arleen: Take walks.

What are you most excited for in the future?
Ken: Continuing.

SoHo

Anthony & Carson
"Really Tall, Cute Guy"

Can you tell us the story of how you first met?

Carson: We met at a party.

Anthony: Pre-game.

Carson: I got out of the taxi, and he noticed me. We made eye contact. I figured he was going to the party, and I texted my friend, "There's a really tall, cute guy here. Should I talk to him?" Then one of his friends came up to me at the party and said, "He thinks you're cute."

Anthony: I asked her on a date, and she said no.

Carson: I was nervous. [*Laughs*]

Then what happened?

Carson: He's the sweetest guy ever. I couldn't resist.

What's your favorite thing about her?

Anthony: How she makes me smile every day. She's funny and she always supports me, which I think is pretty rare.

What's your favorite thing about him?

Carson: He's really smart in a way that isn't just numbers and math. Smart in terms of challenging me to think about things from a different perspective. Sometimes I can be close-minded in the way I think and where I came from. He's really good at pushing me to think things through differently.

What are you two most excited for in the future?

Anthony: A dog.

Carson: Yes. [*Laughs*] That's all.

Anthony: She wants a small dog. I want a huge dog. We have to—

Carson: Compromise.

Williamsburg

Delaney & Sylvain

"Yes, Chef"

Can you tell us the story of how you first met?

Delaney: We met at a restaurant in Paris. He's a chef. He's French.

Sylvain: I was working.

Delaney: And I was eating with my family. Then I followed him on Instagram, and he sent me a DM, and we realized we were neighbors. In Paris. We live in Paris.

How long ago was this?

Sylvain: Four years ago.

What's your favorite thing about him?

Delaney: He has a ton of energy, literally never stops.

What's your favorite thing about her?

Sylvain: I think we're the same; we complete each other. It's a nice energy between us.

What's it like dating a chef?

Delaney: I eat well all the time.

What's your favorite thing he makes for you?

Delaney: Fried rice.

What are you most excited for in the future?

Sylvain: The marathon on Sunday.

Delaney: Yes, we're in the marathon.

Sylvain: Yes, that's the most exciting thing.

📍 *Williamsburg*

Lane & Mark
"Fell Down Stairs"

Can you tell us the story of how you first met?

Lane: We met when I fell down a staircase in a hotel in Hanoi and landed on him.

How did you go from falling down the stairs onto him to dating?

Lane: It turned out that we were on the same trip—it was a group trek around Vietnam. By the end of the trip, we decided we wanted to start a relationship. He was living in London and I was living in New York. We commuted back and forth for a year, and then I got a Fulbright to go work in London. We lived there for two years and then made the decision to come back to New York.

How long ago is this?

Mark: Twenty-seven years ago.

What's your favorite thing about her?

Mark: She's very smart.

What's your favorite thing about him?

Lane: He is the most interesting person I've ever met. I couldn't spend twenty-seven years—

Mark: She's kidding. I'm rich.

Lane: He's not rich.

[*Laughter*]

What are you most excited for in the future?

Lane: We both retired recently, so just having time to do all the things that work got in the way of doing together.

West Village

Heaven & Kenneth

"Two Strong Minds"

Can you tell us the story of how you first met?

Heaven: It's really weird. We just saw each other on the corner.

Kenneth: She was ordering a pizza, and I was right next to the pizza shop, and I saw she looked good, and she saw I looked good, so we just started talking.

How long ago was this?

Kenneth: About two years ago.

What's your favorite thing about him?

Heaven: The way he makes me feel. He treats me like a queen. I love that.

What's your favorite thing about her?

Kenneth: Her personality and the love she's got for me.

What are you two most excited for in the future?

Heaven: Where it can take us, because I feel like we have two strong minds and can go far together.

Washington Square Park

Tara & Devin
"Good Moves"

Can you tell us the story of how you first met?

Devin: I'm in a fraternity, and our fraternity was celebrating our centennial. It was an extravagant event at a hotel in Philadelphia. I went with a couple of friends, my frat brothers, to hang out, party, be around the brotherhood. At that time, my now wife was a stranger to me. I think she was hanging out with her girlfriends for the night. Nice, dressed up, and we met on the dance floor. From there the rest is history.

What was your first impression of him on the dance floor?

Tara: The first thing I noticed was that he had a cell phone clipped to his waist. That lets you know how long ago it was. But he had good moves.

What did you do on your first date?

Tara: Oh, wow, that was a great date. He wanted to take me ice-skating, but I'm not an ice-skater, so he took me to dinner at a nice BYOB restaurant in Philly. He brought my favorite wine.

Devin: Then the next day—[*To Tara*] Was it the next day?

Tara: It was a weekend. It was the Martin Luther King holiday. So we went to feed the homeless together.

What are you most excited for in the future?

Tara: We have two kids. I'm such a mom, so I would say to see how our family continues to grow and how our legacy will continue through our children.

Devin: For me, it's about elevation. Just getting to the next level.

SoHo

Joe & Liza
"Destined to Be"

Can you tell us the story of how you first met?

Joe: We met in my hardware store.

Liza: Is that the truth?

Joe: Well, I stole her away from her ex-boyfriend.

Liza: Yeah. I did meet him in the hardware store. But I was with my boyfriend at the time.

Joe: And I was like, "Huh, I really hope I meet someone *like* her." She embodied so much of what I wanted. I wasn't *gunning* for her, 'cause she was with somebody. But then, as it turned out, it was destined to *be* her.

Liza: I felt the same. I thought, "Oh! This guy's so nice. My boyfriend is such a douche; why am I with him?" Now Joe and I have been together for fifteen years and married for ten. So clearly, I made the right decision.

What's your favorite thing about him?

Liza: We still love to have fun together. I think finding someone you can still feel like a kid with even as you get older is super important.

What's your favorite thing about her?

Joe: Her fearlessness. She just gives me so much strength when I feel like I am at my weakest sometimes. [*Joe starts to tear up.*] It's so easy to just… [*Liza leans in to give him a kiss*]… lean on her and be reminded that I can do anything.

Ridgewood, Queens

Ella & Grant

"See What We See"

Can you tell us the story of how you first met?

Grant: We had actually already known each other for a couple of years. We first met at a bartending pop-up that she was running. But then I decided to go to a party, and we bumped into each other there, and then we...clicked. [*To Ella*] How long ago was that?

Ella: A month.

Grant: It's been a month that we've been dating.

Were you friends before?

Grant: Yeah, we were definitely friends before.

What was it like going from being friends to dating?

Grant: Fucking rad.

Ella: Awesome. Yeah.

What's your favorite thing to do together?

Ella: This. Wander around.

Grant: This, yeah. Just see how one thing leads to the next.

Williamsburg

Eric & Leah
"July 4, 1979"

Can you tell us the story of how you first met?

Eric: We met July Fourth weekend, 1979. And we have been dating, mostly, ever since. She played the long game. She got me to move in with her as my marriage was breaking up in the late '90s. We've been living together for—what does that make it? Twenty-five years?

Leah: No, like almost twenty-eight. Yeah, anyway, he was twenty-three and I was thirty-five.

Eric: Robbing the cradle.

Leah: I turned eighty about a month and a half ago.

No.
Leah: Yes.

I thought you were forty-five.

[*Leah laughs.*]

Seriously?

[*Leah laughs some more.*]

Wait, sorry. What year did you get together officially?

Eric: What does "officially" mean? [*Laughs*]

Okay, what year did you first kiss?

Eric: July Fourth weekend, 1979. That was our first kiss.

(continues)

📍 *Crown Heights*

Forty-five years in, what's your favorite thing about her?

Eric: She's so cute. [*More laughter*] Actually? Okay. This is a person who if she has not spent the week helping poor people, helping people in struggling nations, feels like she's letting the side down. Every day since the day I met her.

Leah: This is true.

Eric: Right, so that's just extraordinary.

That's pretty amazing.

Eric: Yes, and of course, she's cute.

What is your favorite thing about him?

Leah: He's super smart. He knows something about everything, really. This is a fun fact about him: He has a vast library in our house, and it's organized by the Dewey decimal system.

Eric: I'm a composer and I do computers for a living, so it's just the way my mind works.

What are you most excited for in the future?

Leah: Well, we just bought a series of Philharmonic tickets. That was exciting and fun for us to do. We had a lot of disputes about it, and we resolved them.

Eric: What this shows you immediately is that we're just looking to the next thing all the time. We are, in that sense, shortsighted, but on the other hand, we've made it this far.

Leah: We go out every week, despite kids, despite everything, and despite our future, or how much money we have to retire on.

Eric: Despite our financial precarity. But the short answer, though, is we're looking forward to her retirement.

Leah: Yes.

Eric: We have no idea how we'll get there from here, but we are really looking forward to it.

All the Ways to Say No to Meet Cutes

Excuse me, are you two a couple?

Yes, we are. But no to whatever this is.	30%
No.	25%
We're friends.	15%
Yes, but we're in a hurry.	10%
It's complicated.	6%
We're siblings.	5%
We're parent and child.	3%
I'm not walking with that person.	3%
I wish.	2%
We're grandparent and grandchild.	1%

MUTUAL FRIENDS

Here are two remarkably common scenarios: (1) Your friend has a party (or plans a dinner, or an outing, or whatever), you meet someone new there, and you start dating that person. (2) Your friend sets you up on a date with another friend of theirs. Forevermore, when you're asked how you two met, the answer will be "Through a mutual friend."

Christine & Hector

"First and Last"

Can you tell us the story of how you first met?

Hector: A mutual friend of ours, George, had a birthday party with all his family and closest friends. I wasn't that close to him at that time, but I got invited, so I went. She was there.

Christine: I was there. Then I asked him to dance.

Hector: Yeah.

Christine: Then we started kissing. And the rest is history.

Hector: It's funny because when we started dating, she was in something of an open relationship.

Christine: You were my first experiment. Now the last.

Hector: I was being experimented on in front of the entire family, so that was fun.

How long ago was this?

Christine: Five years ago.

What's your favorite thing about her?

Hector: Oh, man. There are so many things. She challenges me every day in ways that nobody else does—in terms of just doing her best to make me a better person and to make sure that I'm setting a new bar for myself every single day. That's probably the best thing.

(continues)

SoHo

What's your favorite thing about him?

Christine: Definitely his heart. He has a heart of gold and is one of the kindest people I've ever met. His family is made up of saints. Everybody is just so nice.

What advice would you give to a new couple?

Hector: To communicate. The way that we've gotten past every difficult moment we've ever had together—and we've gone through our fair share—is by being as honest as possible with each other and never shying away from vulnerability. I struggle with vulnerability a lot. In those moments, the only thing you can really do is talk about how you feel. It's difficult, especially for guys, I guess.

Christine: To try new things together as often as possible. When you share experiences, you get to discover each other a bit more deeply and then connect more often, rather than just on the day-to-day things.

Hector: Indulge.

Christine: Yes. Discover together as often as possible.

Sandra & Keyman

"Fancy Meeting You Here"

Can you tell us the story of how you first met?

Sandra: I was walking out of a restaurant after drinks with my best friend and she said, "I want to introduce you to this guy." She's been saying this for a couple of years now. I'm like, "Tick-tock, tick-tock." Either make it happen or not, right? Well, we walk out, and we bumped right into each other.

Keyman: I'm walking down the street, coming in the opposite direction, when I see my friend Lily and said hi to her.

Sandra: You remember the name Keyman. I knew it was the same guy.

Wait, the person she wanted to introduce you to was right there?

Keyman: It was coincidence. I was just walking down the street. I lived around the corner. I was going to pick up take-out food and we just ran into each other.

What was your first impression of him?

Sandra: "He better call me."

What was your first impression of her?

Keyman: Same. "I'd like to meet her."

How long ago was this?

Keyman: Seven months.

(continues)

What's your favorite thing about her?

Keyman: She's a lot of fun. She makes me laugh. [*To Sandra*] You're cute.

[*Kiss*]

What's your favorite thing about him?

Sandra: I adore everything about him.

What are you two most excited for in the future?

Sandra: Italy.

Keyman: Travel.

Sandra: Travel.

Keyman: Time together.

SoHo

Marisa & Aaron

"Caught in Your Eyes"

Can you tell us the story of how you first met?

Marisa: We met at a party. A mutual friend was throwing it. I saw Aaron talking to my friends and I walked up to them. I played it cool, just said, "Hey, I'm Marisa," and—

Aaron: I thought she was with her friend.

Marisa: Yeah, he thought I was dating one of my friends.

Aaron: Then I waited until the end of the night, and I asked her for her number.

How long ago was this?

Marisa: Two years ago.

What was your first impression of him?

Marisa: I thought he was super sexy, and I really wanted to get to know him.

What was your first impression of her?

Aaron: Her eyes just caught me.

What's your favorite thing about him?

Marisa: His communication skills. And his interest in and devotion to having a healthy relationship, and being each other's person.

What's your favorite thing about her?

Aaron: Her softness. She calms me down when I'm upset. She knows how to say the right thing at the right time.

Domino Park

Donald & Eva
"Late Lunch"

Can you tell us the story of how you first met?

Eva: My cousin wanted us to get acquainted, so he arranged a date so we could meet each other.

How long ago was this?

Eva: Forty-three years ago.

What did you do on the first date?

Donald: We went out for lunch.

Eva: At two p.m.!

Donald: No.

Eva: Yes, we went out for lunch at two on a Wednesday, so he could cut it short in case I didn't fit the bill.

Donald: No commitment.

Eva: [*Laughs*]

What was your first impression of her?

Donald: She's beautiful.

What was your first impression of him?

Eva: I found him attractive. Though I was afraid that, by his looks, he wouldn't be Puerto Rican, he would be from the mainland. But he spoke perfect Spanish, so we kept dating.

What's your favorite thing about her?

Donald: Still the same thing.

Eva: Okay, so just the looks.

SoHo

What's your favorite thing about him?

Eva: He's a very fair person, and he can put other people's interests ahead of himself for the common good. And he's still good-looking.

What are you most looking forward to in the future?

Eva: To travel with him, for him to stop working so we can travel together.

Angel & Daland
"Warming Up"

Can you tell us the story of how you first met?

Angel: We met at the beach. I went to the beach that day with a different group of friends than I normally hang out with. I happened to see him there. He was very quiet. I'm a lot more outspoken. I like to engage with people who look like they're disconnected from the crowd. I socialized with him a little bit to warm him up to the group. I didn't think it was a love thing or a connection thing—after the beach, we went out for food with a couple of friends and that was that. But then he DM'd me on Instagram. We started chatting from there, and that's when we went out.

How long ago was this?

Angel: Two years ago.

Two years in, what's your favorite thing about him?

Angel: He's very giving. He will give you the shirt off his back. He supports you in anything. He's like that with everybody.

What's your favorite thing about him?

Daland: His ability to take feedback, understand, and be patient.

SoHo

Lizbeth & Brandon

"Come On Baby Light My Fire"

Can you tell us the story of how you first met?

Brandon: We were going out to K-Town with our friends, and I took a lighter out of my pocket and I told her, "Light my hair on fire." And she grabbed the lighter and lit my hair on fire.

Lizbeth: He didn't expect me to actually listen to him. When I did, he was like, "Oh, okay," and after that we were the best of friends and attached at the hip. Everyone knew we were going to date before we did.

How long ago was this?

Lizbeth: Two years ago.

What's your favorite thing about her?

Brandon: Her smile.

What's your favorite thing about him?

Lizbeth: His values. I see his values in everything he does.

Union Square

Omar & Veronica
"That Gut Feeling"

Can you tell us the story of how you first met?
Veronica: We met at a party. We both showed up early. We had a dance. We exchanged numbers, and then, yeah.... That was four years ago. We just got engaged.

What's your favorite thing about him?
Veronica: My favorite thing—and it makes me crazy at the same time—is he's super generous, *overly* generous. He'll give everything of ours away. He's patient and kind.

How'd you know you were ready to propose?
Omar: I felt it inside. You know when you get that gut feeling in your stomach? I had it.

Why do you think your relationship works?
Veronica: Because we're total opposites. He's so laid-back and chill, and I'm like, "Argh!" I'm a bigger personality, and he's just mellow.

Bed-Stuy

Chris & Nina

"Authentic and Original"

Can you tell us the story of how you first met?

Chris: We were introduced. We went on a blind date.

How long ago was this?

Nina: Sixteen or seventeen years ago.

What was your first impression of him on the date?

Nina: Well, I already knew who he was before. And I didn't think we would ever be a fit—so that's why it had to be somebody else that set us up. But then, my first impression on the date was that he was authentic. That was missing for most dates, in my experience.

What was your first impression of her?

Chris: I was intrigued. She was different than most people I'd been with before.

What's your favorite thing about him?

Nina: He's an odd duck. I don't know. There's something about, when you love somebody, if they do things that, with someone else you might think, "That's irritating," with them you just think it's cute. With him I just think it's cute. It's just unusual.

What's your favorite thing about her?

Chris: My favorite thing is I can just be me.

SoHo

Nicole & Edwin

"Third Time's the Charm"

Can you tell us the story of how you first met?

Nicole: I remember us meeting at our friend's birthday party. Apparently, we had met two times before that.

What was your first impression of him at that birthday party?

Nicole: I thought he was very adorable.

What was your first impression of her?

Edwin: At the time she was with someone else, but I always had a liking on her. We've known each other since college, but then life happened. Then we rekindled six years ago.

How did that happen?

Nicole: We bumped into each other and started hanging out. Then we were hanging out almost every day, and then it turned into a relationship.

What's your favorite thing about him?

Nicole: Definitely his sense of humor.

What's your favorite thing about her?

Edwin: Undying loyalty.

What are you two most excited for in the future?

Nicole: To buy a house one day.

Edwin: Just growing old together.

East Village

Ruby & Laney
"It's a Wonderful Life"

Can you tell us the story of how you first met?

Ruby: We met through friends.

Laney: I was going to a brunch at this guy's house and Ruby was there and—magic.

Ruby: We became friends. Now we're together thirty-one years.

What was your first impression of her?

Ruby: She was just a very wonderful person.

Laney: Oh, really?

Ruby: It's never changed. She gets more wonderful every day, honest to God.

What was your first impression of her?

Laney: Very attractive, very nice, and I wanted to be friends with her.

What's the secret to thirty-one years together?

Laney: Just respecting the other person and not being rigid. Compromising when you need to.

What are you two most excited for in the future?

Ruby: Just to continue being together. It's wonderful. It's just wonderful.

West Village

Gu & Jieun

"You Never Know"

Can you tell us the story of how you first met?

Jieun: We met in Seoul, South Korea. One of our friends introduced us. It was a long, long time ago. We're married now, but we dated for thirteen years.

What was your first impression of her?

Gu: I liked her positivity and her smile. That's how the story began.

What was your first impression of him?

Jieun: He's handsome. Just everything. A good vibe.

What's your favorite thing about him?

Jieun: He has a deep mind.

What's your favorite thing about her?

Gu: She always stands by my side. We've been through highs and lows, ups and downs, but no matter what's happened, she was always there.

What are you two most excited for in the future?

Gu: The most exciting thing about the future is you never know. Everything is still unexplained. So that's what we're excited about.

SoHo

Dakota & Tom

"Cat Tats"

Can you tell us the story of how you first met?

Tom: We met at a restaurant called Bobwhite in the East Village. It was a group dinner with mutual friends. We have a cat now named Bobwhite in honor of that occasion.

What was your first impression of him at the restaurant?

Dakota: I did not like him. [*Chuckles*] We did not talk at all. I was sitting across from him and I was so nervous, because I thought he was so handsome. But it turned into a long night—after dinner we all hit the bar, and we were there for a long time. At some point, we did start talking, which led to the two of us going together at like two a.m. to a DJ set in Times Square. But everybody has different ways of showing that they like someone, and I wasn't getting that vibe from him that night. I thought he had a weird attitude, and he wasn't giving me enough attention. I didn't think we were hitting it off. But afterward, he was really persistent. He would show up at my apartment and just ring my doorbell and come and hang out. He would call me on the phone randomly be like, "What's up?" I'm like, "Who calls people on the phone?" Finally, one thing led to another and here we are, five years later.

What was your first impression of her?

Tom: Our mutual friend Nick, who had invited me to dinner, mentioned to me beforehand that he thought I was going to like her. He showed me her Instagram. And I liked her vibe a lot. Yeah, we didn't really hit it off at first. It took some time. But we lived very close to each other, which also made it easy. We were friendly, or at least I thought so! And then I just made the effort—I would reach out while I was taking a walk, getting a coffee, and let her know I was in the neighborhood.

(continues)

📍 *Washington Square Park*

Dakota: He would not be in the neighborhood! [*Laughs*] He would call me, like, actually call me. That's so forward. And then I grew to really like that.

If she had an online dating profile, what would it say?

Tom: I like what I like, and you can't tell me differently.

Dakota: [*Laughs*]

Tom: You're just so confident in your decision-making. You'll fight for your opinion, you stick to it, and you're not going to change that for anyone.

Dakota: Okay, thank you. I like that. Well, his would be—and this is why I think we match so well together—his would be something like, I'm so easygoing, and I'm always having a good time. In no circumstances is Tom ever upset. No matter what's going on. He always has a smile on his face. He's a mood lifter for everybody in the room.

Tom: Sorry, mine wasn't as nice!

Dakota: We're different people.

What's your favorite tattoo of his?

Dakota: It has to be his Crazy Sal cowboy skull tattoo. It was done by our friend.

What's your favorite tattoo of hers?

Tom: I like this scorpion a lot. It's so well executed that it's photorealistic. And I think the location is perfect.

If you had to get matching tattoos, what would you get?

Dakota: We have a couple already. Tom stick-and-poked them on us. There's Bobwhite, the name of our cat.

Tom: And then we both have this Valentine's Day flash.

If we paid for it, would you get a third matching tattoo?

Dakota: Absolutely.

Tom: We would.

What would you want to get?

Tom: Probably Bobwhite. Our cat. A black cat.

Dakota: Our black cat? I would so do that, yes.

Elinel & Amauris

"Sealed with a Kiss"

Can you tell us the story of how you first met?

Elinel: We were just friends initially. It was a group of friends. And then he texted me one day after we all hung out, and we kept talking after that.

How long ago was this?

Amauris: We've dated for two years, but we've known each other a little longer than that.

What was it like going from being friends to dating?

Amauris: It was fun.

Elinel: We were really comfortable with each other, so it felt similar in a way, because we're still friends.

What's your favorite thing to do as a couple?

Amauris: Kiss.

West Village

ARTS AND CULTURE

Maybe it's a New York thing, but the visual and performing arts—photography, music, fashion, theater, dance, film—bring together many a couple. Common interests, shared passions, and creative mindsets all lead to people finding one another and forging connections.

Billy & Valencia

"Love Through the Lens"

Can you tell us the story of how you first met?

Valencia: We met in LA. I'm an artist, and I flew there for a show I was doing. I saw him, and I said, "Oh, you look really cool. Who are you?" And he said, "I'm a photographer." I told him that I was an artist, and that we should do a photo shoot together.

Billy: So we did. Then she went on tour. And then she came to New York. The day she left, I booked a ticket to London—because she's from London.

Valencia: We've been long-distance for about two years. But I just moved here.

📍 *SoHo*

Yasmin & David

"From Dancing to Dating"

Can you tell us the story of how you first met?

Yasmin: We were dancing at the same dance studio.

What were your first impressions of each other?

David: She had a mystical but cool aura.

Yasmin: I don't know—he was a good dancer.

How long ago was this?

Yasmin: Ten years.

How'd you go from dancing to dating?

Yasmin: We were best friends first, and then something just happened.

What's your favorite thing about her?

David: Her laugh.

What's your favorite thing about him?

Yasmin: He's very patient.

What are you most excited for in the future?

David: More travels.

Yasmin: Family! And eating together.

Flatiron

Kai & Nkosi

"Creative Minds"

Can you tell us the story of how you first met?

Nkosi: We met at an event in 2018.

Kai: It was a vinyl event in SoHo.

What was your first impression of him?

Kai: I thought he was really precious.

What was your first impression of her?

Nkosi: I thought she was very beautiful. I had to double back, like, "Okay."

What did you do on your first date?

Kai: We just chilled in Central Park and went to an antiques store.

What's your favorite thing about him?

Kai: He's really smart, so sometimes it's a little bit intimidating, but I learn a lot from him.

What's your favorite thing about her?

Nkosi: I like how calm she is, and how she teaches me to be calm. How she makes me feel. I have a very active brain, so she helps me relax. I love that about her.

What's your favorite thing to do together?

Kai: Eat wings.

Nkosi: Yeah, eat wings.

Kai: We like to eat. We're foodies. Well, I'm the foodie.

Nkosi: She's the foodie; she puts me on to everything. I only know about Caribbean food.

What are you most excited for in the future?

Kai: Seeing each other's personal growth. We're both artists.

📍 *Williamsburg*

Chris & Clay

"Love Onstage"

Can you tell us the story of how you first met?

Chris: We are both Broadway performers, and we met at an audition for the national tour of *West Side Story*.

Clay: We both got it.

Chris: We went on the road together, we were roommates, and then we fell in love. He asked me out on 11/11/11. [*They show the "11" tattoos on their arms.*] And we got married on November 11, 2019. I feel like I'm talking the whole time! Do you have anything to add?

Clay: No, that's perfect. He was "straight," and then he was not straight, and now here we are, twelve years later!

What advice would you give to a couple in the same line of work, pursuing similar goals?

Chris: Take competitiveness out of the equation. We've even auditioned for the same role in the same show. When one of us gets it, yeah, sure, there's disappointment, but it's less disappointing if you can be a cheerleader for your person. A win for one of us is a win for both of us.

The Theater District

Malachi & Marissa
"Every Day an Adventure"

Can you tell us the story of how you first met?

Marissa: We met two, three years ago. I asked two of my girlfriends what they were doing one night, and they said they were going to this guy's improv class. So I went to his show. And then about five months later, in November, we were at the same Friendsgiving.

Malachi: I had tried to hang out with her that summer, but we just didn't cross paths. When I found out we were both going to the same Friendsgiving, I knew I had to say something to this girl. I had to talk to her. Then she walked in and took my breath away. I couldn't say a single thing. She went straight over to her girlfriends, and I thought, "There's no way I can say something now because it's intimidating." Four days later, I shot my shot, and I said, "Hey, Marissa, this is—"

Marissa: In the DMs. In the DMs.

Malachi: Yeah, in the DMs. I said, "This is a total shot in the dark, but do you want to go on a date sometime?" And she said, "Yes, but you have to ask for my number first." That's how we met.

What's your favorite thing about her?

Malachi: How Marissa loves the small things. It can be simple, like how much she loves a day of random adventures in New York, not having a plan, just going with the flow.

Marissa: There's never a day that Malachi's not down for something. I could ask him to do anything, whether it's nine o'clock in the morning or nine o'clock at night. He has a love of adventure and of life that I really admire.

📍 *Williamsburg*

Michele & Devenere

"Fashion Romance"

Can you tell us the story of how you first met?

Michele: We met during Fashion Week. We were at a party. I saw him, I thought he was cute, and I said hi.

What was your first impression of her?

Devenere: I needed to talk to her. She stood out from the crowd. She was that light, that one light, like a spotlight was just on her the whole time.

How long ago was this?

Devenere: Probably a month and a half now.

What's your favorite thing about her?

Devenere: Definitely her attitude, definitely her thoughtfulness, and definitely her laugh, her smile—it kills me every time.

What's your favorite thing about him?

Michele: He has such a calming presence. He's very nerdy and teaches me a lot of things that I didn't know. I think he's such a beautiful balance to my very type A personality.

What are you most excited for in the future?

Devenere: I'm moving to New York. So moving here, being with her, and seeing where that dream takes me.

SoHo

SCHOOL DAYS

There's something uniquely charming about couples who met during their school years—whether in elementary school, high school, or college.

For some, they were childhood sweethearts who found their way back to one another as adults. For others, it was college (a time when you're meeting more new people than almost any other phase of life), figuring out who you are and, sometimes, who you want to be with.

What's especially lovely is how many of these early connections turn into lasting ones. Across all stages of school, from playground crushes to campus relationships, these love stories remind us that sometimes the right person has been beside us all along.

Jiries & Katie
"Party School"

Can you tell us the story of how you first met?

Jiries: This is not a good story, actually.

Katie: [*Laughs*] Yes, it is!

Jiries: It was at college. They have this thing called Syllabus Week, and it was a Tuesday. We had Tequila Tuesday, and I met her at a house party. It's the story we've got to deal with telling in the future.

[*Katie and Jiries both laugh.*]

What was your first impression of her?

Jiries: I thought she was gorgeous.

What was your first impression of him?

Katie: I thought he was so cute and sweet.

This was how long ago that you met?

Jiries and Katie: Four years ago.

Katie: We haven't been dating that long, though.

Jiries: Our one-year anniversary was about a week ago.

One year in, what's your favorite thing about him?

Katie: He's very patient and so kind. He's just very supportive of everything I want to do.

What's your favorite thing about her?

Jiries: Her strong mindset—her ambition, her passion, is like no other. She inspires me every day.

SoHo

Terry & Arika

"Sharing the Journey"

Can you tell us the story of how you first met?

Terry: We met in college. Ten years ago. Arika was on the dance team, and I was a student athlete. We met in the cafeteria. I walked up to her and said, "Hey," just trying to get to know her.

What was your first impression of him?

Arika: He was the best friend that I could imagine.

What was your first impression of her?

Terry: I thought she was beautiful, and that this was a great opportunity to meet someone really nice.

What are you most excited for in the future?

Terry: Growing and learning together. There's no telling what's going to happen next year or in the next five years or whatever. It's been nice sharing this journey with Arika.

Tribeca

Lamin & Brittany
"Nursing Love"

Can you tell us the story of how you first met?

Lamin: We were friends in nursing school. We always knew there was something there, but we weren't ready for each other. Then two years later, we started talking and we hung out for the first time. We felt there was something more. After that, I called her on Halloween and said, "Hey, let's take this further."

Brittany: He was like, "Let's do this thing." When he called, I was doing my face makeup for Halloween. I was Shego from *Kim Possible*, so I had one green eye, one black eye. I had to wash my makeup off when he called me so I didn't look crazy as we were trying to have a serious conversation.

What's your favorite thing about him?

Brittany: His ambition. I feel like he genuinely loves life and loves the person that he is. It's cool to go on this journey with him as his girlfriend, but it's also cool to sit in the front row and see the things he accomplishes. Everything he says he wants to do, he gets done.

What's your favorite thing about her?

Lamin: Her energy. She has this light that surrounds her. She makes everyone's day better just by being near them.

What are you most excited for in the future?

Brittany: Right now we're travel nurses, so continuing to see different cities. Continuing to grow. I know that every day with him is not going to be perfect, but life is just perfect with him. It works. We're learning from each other, so growing as a couple and as individuals.

Chelsea

Gabrielle & Albert
"More Than Friends"

Can you tell us the story of how you first met?

Gabrielle: We went to college together. We were best friends, and then we started dating at the end of college.

How'd you go from being friends to dating?

Albert: It was our senior year. We just started getting closer and closer. We were nervous.

Gabrielle: We both really liked each other for a while, but we were with other people on and off.

Albert: I remember she tried to set me up with one of her friends. The whole time I'm just like, "No, no, it's not my kind of thing." We started talking a lot and it flourished into something more.

How long have you been together now?

Albert: Seven years. I just proposed to her.

Gabrielle: Yes, we just got engaged.

Congratulations. Seven years in, what's your favorite thing about him?

Gabrielle: He's so willing to put my needs and comfort before himself. He's selfless.

What's your favorite thing about her?

Albert: She's the most caring person I've ever met. It's so endearing and something that attracted me to her from day one. What she says I do for her—she does that for everyone in her life. It's something I've always loved about her. I'm so happy to be with her.

SoHo

Martin & Julia
"Step-by-Step"

Can you tell us the story of how you first met?

Martin: We went to college together, at Fordham University (go Rams!). She was in the Alvin Ailey dance program, and also majoring in gender studies. We met each other at the library.

Julia: Through mutual friends.

Martin: Friends and I were in the library one day, and I saw this really pretty girl.

Julia: I worked at the library. Student work.

Martin: We started talking for about twenty minutes. We didn't hang out again for a while.

Julia: Right, maybe not for a few months.

Martin: And then you approached me…

Julia: Yeah. He was a photographer and film and communications major. And I was doing my senior thesis. I needed somebody to photograph it and to help me with some of the marketing. He started coming to rehearsals.

Martin: I thought she was really cute.

Julia: I also thought he was cute. That was the bonus.

Martin: We started working with each other. I was in the rehearsals for the show, doing video, photography, things like that, helping with promo. We kept it very friendly and formal for a little while, so I felt weird asking her out. As time went on, we became really good friends. And then she started flirting with me, so I thought, "Okay, I think we can do this now."

Julia: He asked me out.

(continues)

📍 *Grand Central Terminal*

Martin: I arranged this date for us at Bryant Park to take salsa lessons there. But I read the calendar wrong. It was actually swing dancing. We both know how to dance salsa, but we don't know how to dance swing, so that was kind of fun.

Julia: We were stepping on each other's toes the whole time.

Martin: Oh God, yes, that was—

Julia: Very different than salsa.

Martin: We still don't know how to swing dance.

How long ago was that first date?

Julia: May 2017.

What's your favorite thing about her?

Martin: Her willingness to trust people. I'm very skeptical. I go into interactions not thinking the worst of people, exactly, but I'm not going to open my heart to strangers—whereas Julia is very open and willing to welcome people in. That's really beautiful, and it balances me out.

What's your favorite thing about him?

Julia: The way he cares about the people in his life. He treats everyone like family, and he treats his family like gold, and he's just so generous and loving with everyone—

Martin: Not with strangers, though.

Julia: —which balances me out, because sometimes I'm naive. And I love his curiosity about people.

Joyce & Gordon
"A Million and a Half Years Later"

Can you tell us the story of how you first met?

Joyce: I was five. He was seven. I was staying at my mother's friend's house because my mother was in the hospital, and the friend lived next door to his family.

Gordon: I owned the neighborhood. I had a fort. She went into my fort.

Joyce: I did. I went into his fort.

Gordon: We got into a physical fight.

Joyce: Grass stains, pulling hair—it was a big fight. Like Pigpen, dust everywhere.

Gordon: My father comes home. He whips off the belt. That was enough of that. Then, in high school, Joyce and I started dating. And here we are, a million and a half years later.

Joyce: He was the basketball star.

How long ago was this?

Joyce: In 1972, I claimed him as my boyfriend. And I married him in '82.

Gordon: That makes fifty-two years.

So, fifty-two years in, what's your favorite thing about him?

Joyce: He paints; he's a painter. Someday he's going to be very famous.

What's your favorite thing about her?

Gordon: She has put up with me forever.

(continues)

What are you most excited for in the future?

Gordon: Well, the future's dismal.

Joyce: No! Grandchildren!

Gordon: I am a degrowth advocate and anti-capitalist who studied Marxism in college, and I really think the world's pretty fucked.

Joyce: No! Grandchildren!

Gordon: Pretty fucked. I think the total ignoring of the real situation of the planet, the whole bit, is pretty horrible.

Joyce: He's more of a pessimist. I'm more of an optimist.

Gordon: I'm not a pessimist. I'm a doomsday theorist.

What is the secret to over half a century together?

Gordon: Good sex.

Joyce: [*Laughs*] That's not true.

[*Gordon and Joyce both laugh.*]

Okay, Joyce, what do you think it is?

Joyce: We're on our way to the Met, okay? We got a Friday afternoon off, and we're going to go see some art at the Met. We both love to do the same things together.

📍 *Williamsburg*

Dillon & Nautica

"Ice-Skating"

Can you tell us the story of how you first met?

Nautica: We met in college, in 2019. We've been together six years now. [*Chuckles*] Actually, our friend tried to set us up and we didn't like each other in the beginning, which is crazy. I can't imagine my life without him now.

What did you do on your first date?

Nautica: We went ice-skating at the school skating center. I almost completely busted my face open.

Dillon: I remember that day.

What's your favorite thing about him?

Nautica: How caring he is. And how I never have to be scared to be myself around him at all.

What's your favorite thing about her?

Dillon: How loving she is, how she puts everybody else first and then herself. She makes sure everybody else is okay and well.

What advice would you give to a new couple that just met and want to make it six years together?

Nautica: I would say patience is key. Don't let the little things, little fights, ruin the relationship. You have to want to be there. You have to put in the work. I think a lot of people don't realize that no matter if you're married or you're in a relationship or you're just starting out, it's work. It's always going to be work.

Dillon: I would say to be yourself. Don't try to accommodate your other person by being someone you're not. Just be yourself, and they'll accept you.

📍 *SoHo*

Joe & Sophie
"Love and Friendship"

Can you tell us the story of how you first met?
Sophie: I went to college with his best friend from high school. That's how we met.

How long ago was this?
Joe: 1989. We started dating in 1990.

What did you do on your first date?
Sophie: Probably something cheap because we were in college.

Joe: Yeah, we probably just went out to eat someplace cheap. Very cheap.

What was your first impression of her?
Joe: [*Chuckles*]

Sophie: I'm afraid.

Joe: I was drinking in this basement apartment, and she came down the steps and somebody yelled out her name, and she waved her arms. And then we became very good friends, and she was the funniest person I had met in a very, very long time.

What was your first impression of him?
Sophie: My first impression was that he seemed like a really warm and nice guy.

Thirty-five years in, what's your favorite thing about him?
Sophie: He is warm and really nice! And a great protector and my best friend.

Williamsburg

What's your favorite thing about her?

Joe: She is extremely fun and extremely smart and the love of my life.

Sophie: Ditto.

What's the secret to thirty-five years together?

Joe: Do we have a secret? I don't think it's a secret necessarily.

Sophie: I think it's being friends first. It was only a year that we were friends before we started dating. But it really gave us time to understand who the person is. Then, also, growing up together. We've known each other since we were nineteen and living life together. Here we still are.

Joe: It's important that it's a partnership in every way. If you can't rely on your partner, then there's an issue. It's not about you, it's about *us*.

Melissa & Bradley

"From Geometry to Prom"

Can you tell us the story of how you first met?

Melissa: We met in high school. We were in geometry class together. I was a freshman, and he was a sophomore.

What was your first impression of him?

Melissa: I liked him.

Bradley: That's it?

Melissa: Yes. I had a boyfriend at the time. It was complicated.

What was your first impression of her?

Bradley: We sat across from each other. She was always happy and giddy, and laughing. I thought she was really cute and ended up just talking to her.

How'd you go from geometry to dating?

Melissa: He asked me to prom. We went to prom together. When was that?

Bradley: 2012.

What's your favorite thing about her?

Bradley: She's honest. That's hard to find. True honesty.

What's your favorite thing about him?

Melissa: He's the kindest person I've ever met.

What are you most excited for in the future?

Bradley: Everything. It's a cop-out, but everything. Finding out how we traverse the turmoils of life together.

SoHo

Zoe & Selorm

"Has My Heart"

Can you tell us the story of how you first met?

Zoe: We met at school. And now we work together. And one night, I drunk-texted him that I liked him. [*Chuckles*]

Selorm: Yes. Five years ago, in February.

What was your first impression of her?

Selorm: She's bubbly. Talkative. Outgoing. Vastly different from me. Our friends set us up to go to the first-year formal together. I guess she was my date at the party. She came up and started talking to me. I told her, "You're acting suspicious. You don't even know me like that."

What's your favorite thing about her?

Selorm: How she cares about other people. She has three younger brothers, and she's like a second mom to them. The way she goes out of her way for everyone else really has my heart.

What are you most excited for in the future?

Zoe: To fall in love with different versions of him. As we grow old, we're going to change and evolve and become different people. I'm excited to love each version of that.

West Village

Julie & Jerry
"West Side Y"

Can you tell us the story of how you first met?

Julie: We were in a writing class. We were up at the—

Jerry: West Side Y. Twenty-three years ago.

What were you writing about?

Julie: It was a memoir class. I was writing about a cross-country trip that I took in the 1970s.

What did you do on your first date?

Jerry: I don't remember. But you know how she got me? The West Side Y used to have an eating area. I was sitting there, and we hadn't really met. But she gave me this book by—[*To Julie*] Who was it by?

Julie: David Lodge. If you don't know David Lodge, check him out. Great author.

What's your favorite thing about him?

Julie: His curiosity and sense of adventure. He's very loving and supportive.

What's your favorite thing about her?

Jerry: She's the best in all aspects of our relationship.

What's your favorite thing to do together?

Julie: We make fires. We like to build fires in a fireplace.

Jerry: We're mesmerized by the flames.

What advice would you give to a new couple?

Julie: Have fun; take your time. Get to know each other. Be nice to each other. Be patient with each other. Don't judge each other.

Park Slope

The Thing Couples Are Most Looking Forward To

What are couples most excited about for the future?*

♥ **Travel**	**20%**
♥ **Marriage**	**15%**
♥ **Having kids**	**12%**
♥ **Becoming grandparents**	**8%**
♥ **Just doing the same thing they are now**	**6%**
♥ **Seeing each other grow and change**	**6%**
♥ **Retirement**	**6%**
♥ **Their next meal**	**6%**
♥ **Taking life as it comes**	**5%**
♥ **Buying a house**	**4%**

♥ **Getting a pet** 3%

♥ **Activism** 3%

♥ **A new political climate** 3%

♥ **Financial stability** 2%

♥ **No longer being long-distance** 2%

♥ **World peace** 2%

♥ **Moving out of NYC** <1%

♥ **Career progression** <1%

♥ **Freedom** <1%

*These are our qualitative findings on the nature of love, based on interviewing thousands and thousands of couples on the streets of New York City. Like emotion itself, this data is entirely subjective.

Acknowledgments

To every couple who stopped, opened up, and shared a piece of your story with us. You are the heart of this book.

To our community—the millions who've laughed, cried, and felt something real through these stories—we wouldn't be here without you.

A special thank-you to: Bridget, for your words and storytelling; Jeremy, for your creative eye; Shoshana, for your thoughtful edits; Zach, for your insight; and Dan and Kelly, our agents, for your guidance and belief in this project from the start. And to the entire Artisan team—thank you for bringing this book to life with care and intention.

♥

Victor, Aaron & Jeremy

The Authors

Aaron Feinberg, Jeremy Bernstein, and Victor Lee are the creators of Meet Cutes NYC—a storytelling project that began with three friends and a hunch that there was something meaningful about hearing real people talk about love on the spot, just as they are. Since then, they've built a global community of millions by capturing spontaneous, unscripted moments of connection on the streets of New York. This is their first book.

Jeremy Cohen is a New York City–based photographer, with a focus on photographing people and the culture that brings this city to life. His work centers on human connection and, in this book, love stories of the city.